STYLE FOR LIFE

STYLE FOR LIFE

Prunella Stack

PETER OWEN · LONDON

PETER OWEN PUBLISHERS
73 Kenway Road London SW5 0RE

First published in Great Britain 1990
© Prunella Stack 1990

Permission to use quoted material in this book has been granted by courtesy
of the following: The Trustees for the copyrights of Dylan Thomas for lines
from 'Do Not Go Gentle Into That Good Night'; Macdonald and Co
(Publishers) Ltd for an extract from *Easy Does It* by Lesley Hilton.

British Library Cataloguing in Publication Data
Stack, Prunella, *1914–*
 Style for life.
 1. Women. Physical fitness
 I. Title
 613.7045

 ISBN 0-7206-0752-3

Printed in Great Britain by WBC Bristol and Maesteg

ACKNOWLEDGEMENTS

My grateful thanks to my Health and Beauty Exercise colleagues Pat Rowlandson, Margaret Peggie and Lucy Martin for helpful advice; Elizabeth Mallett for permission to reproduce the post-natal exercises; Joan Scott for her exercise drawings; and Kathryn Wilson for typing the manuscript. My editor, Beatrice Musgrave, has given me invaluable encouragement and suggestions throughout for which I am truly grateful.

P.S.

CONTENTS

ILLUSTRATIONS

(between pages 38 and 39)

INTRODUCTION

The Qualities of Style

I am a grandmother in my early seventies. I have reached what used to be called old age but is now known as the mature years. I realize where I am, but still remember very clearly how I felt when I was a teenager, a young mother, a middle-aged woman or on the way to becoming an elderly one.

At seventeen I could not imagine living beyond the age of thirty. Yet when thirty came I was as immersed in life as ever, and as each decade approached, the time of my expected demise miraculously receded. Another strange thing happened. The older I got, the faster the years flew. Finally, I realized that each decade should be accepted for what it was and lived through without nostalgia for the past or fears for the future. I saw that the present, what was happening here and now, was all I could be truly sure of. I decided to make the most of it.

This book is an attempt to share that experience. Why have I called it *Style for Life*? Because to me style means an attitude of mind, positive rather than negative, as well as a certain physical distinction. Finding your own style entails defining your own needs, developing imagination and flair; also, being discriminating, so that you do not conform without thinking to an imposed outer standard but create your own image of what you want to be, working from within. This kind of style is a way of living and being which renews itself each day, a reservoir from which strength and wisdom can be drawn.

Although it may take a lifetime to perfect, its roots are already there in the youngest child. Every mother knows how her baby possesses its own personality and character from the day of its birth. Given the necessities of food, care and shelter, it will express from the beginning its distinctive likes and dislikes, frustrations, irritations and satisfactions. And no two children

1

respond in the same way. One of the fascinations of a large family is seeing how differently each child develops. Within each are the seeds of the particular style he or she will later adopt.

My grandchildren, two girls aged eighteen and nineteen, have lately reminded me of this fact. They are influenced by their parents, but now their time for experimentation and discovery has come. Learning from their mistakes, probably rejecting some of the accepted wisdom they have been taught, using their imagination and gaining confidence in their ideas, they will create their own style. Watching them, I am vividly reminded of my own youth.

I was an only child, but I was lucky to be brought up by a mother who was an example of natural, unselfconscious style. Her good looks helped her; so did her good figure, kept in trim by health exercises which she practised every day and passed on to me. They were part of the self-discipline which, being Irish and a dreamer, she had forced herself to learn. But as well as possessing a magnetic personality, she had certain rules about her appearance which I treasure to this day. Most of them were related to health.

She taught me that the essential basis of beauty is a healthy body; that the natural effects of sunlight, fresh air and exercise have a more lasting influence on looks than any number of artificial aids; and that charm and good manners come first and foremost from within. She also allowed me the independence to develop my own style.

At thirteen, I began a dance training at her Bagot Stack Health School which gave me rhythm, co-ordination, grace of movement and an apparent sophistication beyond my years. But at heart I was still a child, picturing myself as the heroine of some momentous adventure in which my courage and resourcefulness would win the day. My mother laughed at me, teased me, but respected this fantasy, and meanwhile showed me how to attend to every detail of my appearance.

This was especially important before any public engagement, and there were many of these for her students, both on- and off-stage. For a performance, or for a photographic session, I had to be meticulously groomed – hair, face, hands, nails, feet (these were usually bare, as I was dancing). I also had to prepare the changes of clothes I would need and present them washed and pressed, ready for the occasion. 'Make yourself look as nice as you can

beforehand,' my mother would say, 'and then forget about your appearance and throw yourself into whatever it is that you are doing. And if at a party you are asked to dance or sing, *do it*. Contribute. Don't be self-conscious or shy.'

All this was excellent training for style. And when, at seventeen, my inner image of a heroine changed to that of a vital, poised and charming young girl, it stood me in good stead.

Today the style of the young is very different, as my granddaughters and their friends have taught me. It is both more casual and more glamorous. Day clothes are practical and workmanlike, allowing for the active life the young lead. Large shirts and jerseys, often interchangeable with those of their boyfriends, are in fashion as well as being comfortable. Short skirts or trousers allow a wide stride, and shoes with the low heels I longed for but never could find when I was a tall teenager are designed for walking or running. Girls no longer dress to please men; they dress to please themselves. Daytime fashion is influenced by a casual sporting image. The careful grooming of my youth – tidy hair, stocking seams always straight, gloves and hats in place – would seem ridiculously restrictive now.

But in the evenings everything changes. The transformation is striking. Glamour is laid on with an expertise I never knew, helped by the many beauty products now on the market. Eye make-up, lipstick and hair colour are all used from a comparatively early age. I first used a lipstick when I was nearly twenty, my granddaughters when they were thirteen. Ethnic clothes, dramatic effects, outfits to surprise or shock are all experimented with. Yet however exotic the appearance, freshness, variety and care still matter. The general effect and the choice of detail still depend on the *person* behind the clothes and the make-up. The exterior can never be more than an expression of what lies within.

While I was being brought up to believe this, I also had to learn how to train my body – the foundation of style – so that it could be expressive, efficient and healthy. In the early thirties, my mother founded a movement called the Women's League of Health and Beauty, which aimed to provide exercise and dance classes for women throughout the country – a service to health which also offered a means of release and expression. Health and beauty became the fashion. In the first two years 50,000 women joined

the League and I found myself in the forefront of the campaign.

How did this affect my style? My inner picture changed to that of a dauntless young leader in the vanguard of a movement which would shake the world! The League's aim was health leading to peace, and I firmly believed in it. So did my mother, who maintained that training women to be healthy and to rear healthy children would have a marked influence on future generations. We behaved like crusaders for a cause. I was constantly in the public eye and my self-image had to include unbounded confidence. I also had to think carefully about my appearance and prepare for public engagements with foresight and imagination. These engagements ranged from leading cohorts of League members into Hyde Park or the Albert Hall to demonstrate their exercises (for this I wore a short white tunic with a wide silver belt); speaking at large public dinners (full evening dress); and, on two occasions, attending afternoon parties at Buckingham Palace (hat, gloves, shoes, and dress – all immaculate).

In private life clothes could be more casual, though of course I dressed up for parties or dates with boy-friends. But I was happiest with a natural style, looking as though I had just come in from out of doors, sunburned and wind-blown. This was my mother's style too, though she adapted it for her lectures and demonstrations to a more sophisticated one, and always took great pains to wear what would fit the occasion. In this way four exciting years passed as we worked together to spread the work of the League: role models for an increasing number of women.

Then, early in 1935, the unthinkable happened. After a six-months illness my mother died of cancer. My father had been killed in the First World War when I was a baby, so at twenty I was alone. My life, which had been light hearted and protected, suddenly became serious and responsible. The League, my mother's life-work, had to continue. Trying to achieve this kept her close to me. But the demands it made on me as it grew to over 100,000 members were extreme.

I worked very hard. I was at the League headquarters in central London each day at 9.30 a.m. Four nights a week I taught exercise and dance classes until 10 p.m., and during the day I fitted in the training of students, committee meetings and interviews, press publicity and outside public engagements. For most of these I had to present a businesslike though still feminine exterior, and to

find the sort of clothes which would enhance it. It was a relief in the evenings to don my League exercise kit (diminutive black shorts and a white blouse) or a leotard or tunic for the classes I took. Getting into those friendly clothes comforted me. They represented a kind of discipline for what was now expected of me.

I realized then as I have realized since that a terrible personal event such as the loss of one's mother at an early age must somehow be fitted into a pattern so that it can be absorbed and accepted. In such a case the outer image of a familiar style is a great help. However sad the heart is, life must go on.

A brave face shown to the world allows this to happen and also determines other people's reactions, avoiding embarrassment and leaving room for sympathy and support. When I was working I had these in good measure, as well as companionship. My mother had trained a number of young teachers who were as keen as I was to see the League continue. But after the day's work was over a vacuum opened that was hard to fill. I was experiencing what every woman knows who has a career and puts it first. All my energy went into my work at the cost of leaving me often irritable and exhausted. After some time had passed and I was able to accept my mother's loss, I realized that I must take a long hard look at myself. What I saw was a girl too dedicated for her own good. I was losing my sense of proportion and my sense of humour; failing also to see how much others besides myself were contributing to the League's success. I needed to remind myself of the old Greek principles of balance and the golden mean.

Today not only women with a career but many others as well are living with a sense of pressure. The planet has shrunk. The trouble spots of the world are flashed nightly on to our TV screens. So are advertisements which whet our appetites, raise our expectations, and imply that when these are satisfied lasting happiness will ensue. But does it?

We sit in traffic jams, furious with frustration, while our bright new cars tick over. We drink a glass of wine in a special place with a special companion, and we quarrel. We use that magic new washing powder in a shining washing machine and the machine sticks and floods the kitchen. Who will mend it? Finding a plumber takes an hour on the telephone. In cities, we

live in a polluted atmosphere and eat processed foods. When we want to leave them we have a choice of crowded stations with queues for trains, impersonal airports where we become automatons, or motorways with traffic jams building up as flashing lights indicate yet another set of road-works.

These things are part of everyday living. We contend with them but often have a sneaking feeling that we are not doing as well as the lady on the TV screen.

The instances I have given relate chiefly to the higher-income groups of society. At the other end of the scale the tasks of finding and keeping a job, and providing food and shelter for one's family, are sufficiently urgent and absorbing to preclude imaginary needs. The pressures are more real and more extreme. Even so, most people today believe in the power of money and material goods to confer happiness.

I found out at an early age that the concept of style meant looking at *myself*. I had to try to become my own magic helper. From there it was a logical step to look at the situation I was in, and to realize I was only a part of it, not its centre. This led to objectivity.

Objectivity is a vital quality for coping with the irritations of life today. Imagine yourself in any of these situations. You are stuck in a traffic jam and do not know when your car will move on. Instead of keeping your eyes glued to the clock and thinking about the appointments you are missing, switch off the engine and turn on and listen to your favourite music, classical or pop.

You have a tyre blow-out on the motorway. The AA is summoned but cannot reach you for an hour. You are in the country and it is a beautiful sunny morning. Get out of the car, lock it, climb over the fence beside the road, sit down in the meadow and watch the cows grazing. This actually happened to me when I was driving up to Scotland two years ago.

Your plane is late taking off and you may have to wait for some hours. Resist the duty-free shop, shut out the noise of airport announcements, find an unoccupied seat and open the absorbing book you have brought with you. (Don't get so carried away that you miss the plane!)

I admit it is difficult to be objective when your washing machine leaks all over the kitchen floor. The only attitude then is one of resignation as you get down on your hands and knees to

mop up the mess. This may be the moment to take a cool look at your style of coping with minor adversity as though you were a stranger observing another stranger. Performers on TV know how revealing a sight of themselves on the screen can be. In this age of the video, the opportunity is open to many of us to watch ourselves from the outside and perhaps try to change what we see if we do not like it.

Imagination is another important quality of style. It is essential in forming the picture you want to present to the world and vital when dealing with others. The poet Keats said: 'A man to be greatly good must imagine intensively and comprehensively . . . the pains and pleasures of his species must become his own.' Without going quite so far, it is very helpful when you are misunderstood, or when someone criticizes your latest example of style, to be able to imagine why.

Some people have antennae of sensitivity which record at once what others are thinking and feeling. Although recording does not necessarily mean agreeing or approving, it does make for understanding. Failing this, imagination has an instructive part to play.

Imagination is also the basis of every creative work. Labour and thought and choice are needed to complete it, but imagination gives it birth. It does the same for style.

When, in my twenties, I was discovering a style of my own, I set great store by originality. I had an aunt who was a dress designer and who owned an exclusive shop in South Molton Street in London's Mayfair. I used to stand for hours while she pinned her creations on me and afterwards gave me some of her dresses to wear. At their best, they were beautiful – original and romantic. Chiffon was her favourite material for the wide full skirts of the evening dresses we wore then. Some of her designs were too extreme or too sophisticated for me. Nevertheless, she made me realize that originality was something to be sought after in style, though it needs the right wearer and the right occasion.

For the young it is still top of the list. In an age of standardization they seek it as a mark of their individuality and recognize it with joy. Originality plus experimentation plus imagination is their formula for style.

Sadly, as we grow older we become less adventurous in every

way, including our choice of clothes. However, there is still opportunity for variety. Sometimes there seems to be almost too much. Fashion changes more quickly and is more widely disseminated today than ever before. There is no lack of advice on what to wear, how to wear it, and where to buy it. In the fashion magazines and fashion pages of the daily papers, you can find a wide choice of clothes you like at a price you can afford. The task then remains of finding time to search for them in the shops and fitting them to the demands of your own life.

I usually try to fulfil the last consideration before the first. I find it *is* possible to look forward to the next six months or so, and to determine what clothes I will need for the events to which I am committed or that are likely to arise. It helps to divide these occasions into everyday, special, holiday, and public. I then review what is already in my wardrobe and ask myself how it could be added to for variety, perhaps with a fresh shirt, belt, scarf or jersey. Finally I decide what entirely new outfits I need and can afford (whether a coat, a dress, a suit or separate components of these). I find this homework gives me an invaluable framework on which to rely amid the great variety of choice in the shops.

The danger with this method is that one tends always to wear the same kind of clothes. Variety is more than adding a new belt or scarf to an outfit. It requires a leap of the imagination and a fresh inner picture of oneself. Sometimes outer circumstances impose this. You change your job and need to present a different kind of personality for the new one. You change the country you live in and are immediately influenced by your new environment. You go on holiday and are fascinated by the local clothes you encounter. Or you become tired of your appearance being taken for granted by people and long to give them a shock!

You feel adventurous. So, open your mind wide and forget preconceived notions. If, when shopping, you suddenly see something of stunning originality or appeal, snap it up. It may be the best buy you ever invested in or you may regret it, but either way you have had the courage to depart from your normal way of doing things and brought variety into your style.

Hand in hand with variety goes discrimination, perhaps the most essential quality of style. It is the basis of taste, for no matter how original or imaginative your ideas may be, without discrimination they will founder. Discrimination comes with

experience – sometimes a lifetime's experience – and is often the result of a number of mistakes and false trails.

I can remember one or two sartorial disasters in my youth when I failed to discriminate between what looked marvellous on a model and what suited me. One such choice was a bright yellow linen suit with a closely fitting jacket and straight skirt. I elected to wear this on a long train journey north for a speaking engagement in Yorkshire. I arrived at the station with every button on the jacket doing its duty (I was verging on the plump in those days) and a skirt so tight that I had difficulty getting on to the train. Discomfort increased on the journey. By the time I reached my destination the linen skirt was irretrievably creased, smuts from the engine had damaged the jacket's freshness, and I was beginning to regret its harsh yellow colour close to my face, now pale with fatigue.

Discrimination almost always has to be learned the hard way. When related to appearance, it derives from a clear picture of your own style, a knowledge of your strong and your weak points, and an ability to enhance or disguise them. In a wider context, it acts as a filter, helping you to reject false glamour and meretricious advice, and to resist temptations which are not right for you.

There are other ways also in which discrimination is valuable. It can help to select the right clothes for each occasion. Here it links with imagination, for to see a mental picture of what is going to happen, how other people will be dressed, and how you will look yourself, is imagination's task. But if imagination indulges in a wild flight of fancy, as sometimes happens, discrimination must step in and rescue you from a wrong or embarrassing choice.

Discrimination can also pick a role model for you to follow until you have acquired enough experience to be one in your own right. When I was young, I had a friend who acted in this capacity for me. She was a tall, beautiful Swedish blonde, who loved clothes and knew a lot about them. Always well dressed, she had a talent for selecting exactly what was right for each occasion. When in doubt, I used to think, 'What would she wear?', until time and experience helped me to know the answer myself.

As one goes through life, one's style adapts and changes, but discrimination remains and deepens. With age, priorities alter. Inner aims and goals become different, and this is reflected in

outer appearance. The transitions between one age and another
– young to middle-aged, middle-aged to elderly – can be difficult.
Discrimination then is of greatest value, advising you what to
discard and what to cherish.

I now come to the last of the qualities which are necessary for
style: physical distinction. This phrase is more often applied to
men than to women. But today, when so many women are taking
on men's jobs and living in a man's world, distinction, both of
appearance and of manner, is becoming more important and
more valued.

Distinction is allied to interesting looks rather than good looks.
It wears better than beauty because it implies an outer
manifestation of inner confidence and strength. It may have its
roots in originality or objectivity but it is expressed in a certain
physical bearing which includes calm and – an unfashionable
word – dignity. Our great-grandmothers, tightly laced into
corsets and sitting for their photographs with an upright posture
and uncompromising stare, often had this quality. I mention this
image not to commend it but as a contrast to the laid-back,
relaxed attitude which is today's opposite extreme.

Modern distinction of style comes somewhere in between,
being an amalgam of discipline and informality. On the physical
plane it includes good body alignment, which can be learned and
acquired by everyone, as well as grace and co-ordination. But
most of all, distinction depends on an inner discrimination which
adds good manners and sensitivity to the more obvious com-
ponents of style.

Pretty women who rely only on their looks to see them through
life's problems may experience a disillusioning adjustment when
their looks begin to fade. Those with distinction will find that age
enhances this quality, bringing them greater freedom to express
themselves in their own way.

'Style is the dress of thought', said G.K. Chesterton. In writing
about the subject, I have tried to give room to reflections which
have developed in my mind during the course of years. I have
watched people's 'characteristic bearing, demeanour or manner'
– to quote an 1826 definition of style – and linked it with their
opinions and behaviour.

Obviously, all the different qualities of style I have described

will very rarely be found in one person. But each of us probably possesses one or two of them, will cultivate more, and recognizes others in people whose style we admire.

My list would include: a positive attitude of mind; confidence; a capacity for attention to detail; objectivity; imagination; originality; variety; discrimination; physical distinction. These nine add up to the most important quality of all – a source of strength for living.

When I first started to think about style in my teens and early twenties, none of these ideas were formulated. Then, I was concerned only with style's outer manifestations: how I looked, what impression I was making, how original and striking I could be. But as the years passed and I carried on my mother's work, as many thousands of women joined the League's classes and hundreds of girls trained to be League teachers, I had the opportunity to observe how closely physical characteristics are related to traits of character and personality.

In teaching these girls and women how to train their bodies to the best advantage, how to improve their figures and how to achieve grace of movement, I realized that perceptions were being released within them which would alter their personal outlook and style.

Today I see clearly that mind, body and spirit cannot be separated. They form a whole, and style, at its best, is an expression of all three.

Much had to happen before I was able to hold firmly to this belief. The war came; the world changed; with peace, my work started again and by then I was a widow with two young sons. The League flourished, building up its membership and in recent years changing its name to Health and Beauty Exercise. Now a grandmother, I gather up the threads of half a century's experience and try to weave them into a pattern which may be useful for these times.

The chapters which follow describe the practicalities of style with, I hope, that attention to detail which is one of its necessities. If the reader is still with me by the end of the book we will have travelled together through five decades and examined what happens, or may happen, in a lifetime of style.

PART ONE

The Ingredients of Style

1 . POSTURE AND BODY ALIGNMENT

We have already noticed that a distinctive style includes good body alignment as well as grace and co-ordination. These depend on correct posture.

The dictionary defines posture as 'the position and carriage of the limbs and the body as a whole'. But for most people the word posture is associated with rules of deportment, discipline and discomfort.

'Stand up straight; hold your shoulders back; lift up your head.' How often we have heard these instructions in our youth. Sitting hunched over a desk encouraged round shoulders. Carrying a heavy school bag always on one side could induce curvature of the spine. Shyness or self-consciousness might stiffen the shoulders or cause the head to droop. Yet as small children good body alignment and freedom of movement were our natural possessions. It was only when the shades of the prison-house of learning began to close that we lost them. The growing body did not have the strength to return to its own correct posture after wrong use, so bad posture often became habitual.

With growth and development came physical and mental tension and also the effects of the unnatural environment in which we all live. Our bodies were attuned originally to running out of doors, not walking on hard pavements; to squatting for meals or leisure, not sitting at a table or lounging in an armchair; to feeling fresh air on naked skins, not being muffled in constricting clothes. They were accustomed to having exercise each day which would increase the circulation, the pulse-rate and the heartbeat, keeping the muscles co-ordinated and in good tone. No wonder we now have to re-learn our natural heritage of correct body alignment.

The sooner this is done the better. I was fortunate enough to

have a mother who possessed a trained and eagle eye, and who could spot any irregularities at once and correct them. Good posture became a habit for me from childhood. Even so, I had physical limitations to contend with: round shoulders because I grew tall and tended to stoop; a slight curvature of the upper spine which my mother cured with her exercises; and stiff hips which I laboured at limbering up every day!

Most people, if they look at themselves candidly, will find similar minor defects. When recognized, these can be alleviated and even cured by the right type of exercise and by the practice of good posture, the basis on which all else rests.

Children start to move by crawling on all fours, thus repeating the pattern of their long-lost four-legged ancestors. When they learn to stand upright the law of gravity exerts its force and at first they are unsteady on their feet. This law operates throughout life. Our bodies are continually adjusting to it, using balance and muscular activity to counteract its pull.

To remain stable, the line of gravity should fall within the area outlined by the feet. The easiest standing position is with the weight evenly distributed between both feet, which are slightly apart. The line of gravity then falls exactly between them. If you stand with the weight on one foot only, the line of gravity runs through this alone. Most people do stand this way, shifting the weight from one foot to the other; they find it an apparently less tiring position. In fact it often throws the hip and pelvis out of line and affects the balance of the body.

A dancer is trained to balance on one foot without upsetting her line of gravity; at the opposite extreme, people with bad backs find it easier to stand on one leg rather than both, or even to alleviate their pain by lifting the other leg on to a chair. But this only works if the rest of the body remains in line and is not distorted into wrong positions.

The force of gravity acts on all the joints of the body, and for them to function in the best way, with the least strain, a harmonious balance should exist. Picture yourself standing sideways. The correct line of gravity should pass from the crown of your head through your ear, your shoulder-joint, your hip-joint, your knee-joint and slightly in front of your ankle-joint. When all these joints are in line the body is well balanced and functioning at its best. Good posture has been achieved!

Unfortunately, getting to this point entails some effort. Often

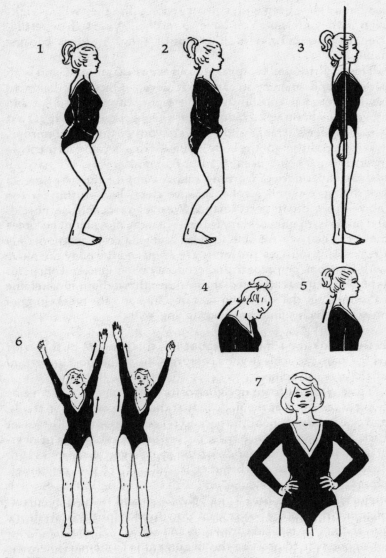

1. Wrong
2. Right
3. The line of gravity
4, 5. Correct alignment of the head
6, 7. The rib lift

bad habits have been with you for so long that they will *feel* right even if they are not. You have to reconcile yourself to getting used to new correct positions until they, in turn, become habitual.

This might sound complicated and even discouraging, but with patience and practice it can be achieved. Once you begin to remind yourself constantly of the right way to stand, sit and move, your brain will gradually get the message; even if at first your body feels strange and awkward your posture will improve.

Wrong positions of the body involve strain because its intricate mechanism is being used in an uneconomical way. We have all had the experience of learning a movement for the first time – a golf swing, a tennis stroke, a dance step – and putting far too much effort into its performance. We over-react and use muscles and joints with unnecessary force. When the movement becomes more familiar we are able to relax and gain co-ordination; only the relevant muscles and joints are used, and the body can move with freedom, confidence and economy of action. And once this type of posture is achieved, it continues throughout life, helping to counteract the wear and tear of joints and the weakening of muscles which comes with advancing years.

Let us think for a moment about the components of this body which wants to achieve good posture. One of the most important of these is the spine.

To adapt itself to an upright position the spine had to develop two curves – one at the neck so that the head could move freely, and one in the small of the back to relieve pressure on the lower back. With poor posture these curves become flattened or over-accentuated. The formation of the spine's vertebrae makes for suppleness and strength but it is still subject to considerable stress – jolted every time one walks, runs or jumps. So it is important that its base – the pelvis – should be held in correct alignment: with the lower back downwards (not hollowed) and the abdominal muscles drawn in and up.

A good way to practise this alignment is to stand sideways in front of a tall mirror, feet slightly apart and knees bent, one hand on the stomach, the other on the behind, so that you can feel what is happening. Hollow the back (wrong position), then bring the lower back down towards the floor (right position) so that the pelvis faces forward and the stomach is drawn in and upwards.

This see-saw exercise with bent knees frees the movement of the pelvis and counteracts a too-pronounced curve in the small of the back. It also gives the feel of the correct pelvic tilt. The action of the abdominal muscles strengthens the abdominal wall, which forms the only protection for the vital organs within. To help it to remain healthy and beautiful, this region of the body requires the daily training that brings good posture, as well as special exercises for abdominal muscles, both described in the appendix.

At the top end of the spine is the head, and its proper alignment is equally vital. The position of the head is often indicative of the emotions – drooping when sad, thrust forward when aggressive or tilted back when shy. It is closely linked with the spine; its slightest movement can be felt in the vertebrae. To gain correct alignment try dropping your head forward with a gentle movement, feeling conscious of its weight. Then slowly roll it upwards, pressing out the back of the neck as though a finger was traversing it and it was responding to the touch. When the head is erect it will be centrally balanced with the chin at right angles to the neck. Imagine a line, stretched and taut, from the crown of your head to the ceiling. Feel your neck lengthening and drop your shoulders downwards away from the head. Both neck and shoulders should be relaxed and the arms should hang loosely at the sides.

With the correct pelvic tilt and a lightly poised head the base and the apex of the spine are in good posture. Next you want to aim for as much space as possible between your ribs and your hips, thus lifting the weight of the upper half of the body off the hips. An easy way to practise this is to stretch your arms above your head in a wide V. Reach as high as you can, first with one hand, then with the other, then with both, up and up as you feel your ribs lifting. Hold this for a moment, then drop your arms to your sides again but keep the lengthened waistline you have achieved. You can check this by placing a thumb on your ribs and a finger on your hip bone and testing the expansion of the space between.

Above your lifted ribs are your shoulders. They should be held level. If you rotate the points of your shoulders outwards so that your palms face the front, and press your shoulder-blades together you will get the feel of your shoulder-girdle widening in front and flattening at the back. Once you have mastered this, relax your arms and let the palms face your sides again.

Lastly, think of your feet. They are the bearers of your body throughout your life. Stand with them a little way apart, balancing your weight evenly between them and leaning slightly forward. If you rise on your toes and then gently lower your heels to the ground your weight will be perfectly adjusted. Dancers are trained to lift up the arches of their feet and stretch their legs so that the thighs are pulled up towards the correctly balanced pelvis – a good position to practise from time to time.

This seems a lot to remember. But once you get a mental picture of the body in good posture it is not hard to adjust yours accordingly, although it takes time and much determination to make the adjustment permanent.

You may be wondering if this insistence on good posture makes for self-consciousness and stiffness, if at the end of it all you will have turned into a beautiful statue which cannot move? Far from it. The next step is to carry your good posture into body alignment when moving.

The aim here is to achieve balance, so that each part of the body can move economically and in co-ordination with every other part. The spine, correctly positioned at the pelvis and the head, is the prime mover and the rest of the body responds in harmony. Balance can be clearly observed when watching a dancer or an athlete performing a difficult feat. It appears effortless and is pleasing to watch because the body is in perfect alignment and quick to answer any demand.

In sport, people often say that *usage* is the best way to correct wrong movement; that in trying over and over again for the best tennis shot or the perfect golf swing poor body alignment will be overcome. I believe that a basis of good posture will achieve the end result much more quickly and will help to avoid injuries because the body is alert to sudden strain.

Exercises which loosen joints and strengthen essential muscles also depend for their effectiveness on correct body alignment. A capable teacher will make sure that her class understands the principles of good posture before giving them strenuous exercises, and will see that these are graded according to the capacity of her pupils. Given these conditions, exercises can achieve dramatic results in improving both health and beauty. A list of suitable ones for all ages is included in the appendix.

This also applies to dance. Much of modern jazz dance consists of attitudes which are asymmetrical rather than symmetrical,

demanding a departure from conventional good posture. But this technique can be practised without harm provided good posture is already known. The body will adjust itself and maintain its alignment even in exaggerated positions.

In the end, lasting results in good body alignment are brought about by the unconscious even more than the conscious part of the mind. Habit and repetition help, but the final outcome stems from a kinetic sense that the movement is *right*. At this point mind and body are in close unspoken harmony, a state best achieved when people are physically relaxed, free from nervous tension and enjoying themselves. An experienced teacher in a dance or exercise class, having prepared you first, will give you the type of movement which encourages mental and physical harmony, accompanied by stimulating or relaxing music, which-ever is appropriate. If you then let the unconscious take over and give yourself to what you are doing without inner anxiety, a fusion of mind and body at a deeper level will occur. This is the beginning of a real and lasting change in your body alignment.

I have so often seen this happen in movement classes which I have taught. At the beginning, people tend to be self-conscious and rather apprehensive of what may lie ahead. As they warm up with some loosening and relaxing exercises their initial tension begins to break down. A period of conscious attention to body training and body alignment follows. Then its principles are put into action in movement. At first the class members learn the steps or exercise routine I want them to follow. But gradually, as they begin to know and repeat these, another force takes over. The conscious mind goes into abeyance and an unconscious kinetic sense is released. This goes back to a primitive accord between mind and body now largely lost to civilized people. With it comes a sense of harmony and exhilaration which affects the whole of the personality. When the class ends, its members are standing, walking and moving quite differently from when they came in.

How does all this affect style? Does one need an unconscious as well as a conscious response to maintain it? If style can be considered an art (which, at its best, I think it is) the answer is Yes. Every art demands the learning and perfection of a technique which is then used as a means of expression.

A pianist or violinist must master his notes and scales, the

position of his fingers on his instrument, the accuracy of his reproduction of the score, and many other technical points before he can become a vehicle for the true expression of the music.

The same is true of a painter, a dancer or a poet. The first uses eye and hand; the second uses steps and body control; the third uses words, rhythm and syntax. All these have to be mastered and understood before the final quality of expression can be properly conveyed. The point is then reached where technique has become secondary. The human instrument is ready for inspiration.

If the same is true of style, then its foundation has to be consciously built before its grand edifice can appear. One of the bricks of this foundation is body alignment.

What do we do during the day? We stand, walk, sit, drive, work, talk, eat, and finally sleep. Each of these activities involves body alignment. We've talked about standing already. Now let's consider walking.

Walking uses more muscles than almost any other activity and is marvellous exercise. You can walk at your own pace for as long or short a time as you like, so it involves no strain and gives you the opportunity to observe what lies around you or retire into your own thoughts if that is what you prefer.

The feet play a vital part. The weight should pass right through the foot from heel to toe with each step. This can't happen if you wear high heels, which send your weight too far forward and affect the angle of your hips. So use comfortable shoes like trainers, and if necessary practise strengthening and mobilizing exercises for the feet each day. Place the foot straight when walking, not turned out or in, and put the heel down first.

The poise of the head and the lift of the ribs above the waistline are also important to remember so that you get a feel of lift through the whole body. Legs swing from the hips with a free movement which has an unbroken rhythm for each step. Walking at a normal pace for thirty minutes uses around 150 to 200 calories – the equivalent of fifteen minutes running or swimming. So it is good for the figure as well as for health and brings a sense of well-being and exhilaration, especially if you can walk on grass or a country path rather than a hard city pavement.

Sitting occupies a good part of the day for most of us, all too often in a slumped position. The important thing to remember

here is that the whole length of the spine should be supported, especially during a prolonged period of sitting when ligaments and muscles surrounding the spine may be weakened. This is easier in an upright chair than in an easy chair. If you sit well back and have a little cushion behind you in the small of your back it can be achieved even when writing or typing at a desk. Once you get the feel of a straight spine and a lifted, poised upper half of your body you will not want to relax it and slump when you sit.

In driving a car your back is upright in the driver's seat but you will probably need the little cushion behind you for extra support. Beware of tense shoulders and neck which may arise from traffic worries. Try giving your shoulders a shrug and a roll when sitting in a traffic queue, and move your head when it is safe to take your eyes off the road. The movement of a car affects the spine at every level (as anyone who has driven with a spine injury will know), so try to keep your posture easy and relaxed, ready to respond to the car's rhythm, like a boat on a wave.

Physical work of any kind – whether in a house, a garden, a factory or on a construction site – involves positions which require good body alignment. Bending is one of them. I remember watching with envy African women weeding or planting in the fields and bending forward from their hips, with a straight spine and straight legs, when they wanted to reach the ground. Few of us are supple enough to do this. But bending with a rounded back throws a strain on the sacro-iliac joint where the spine meets the pelvis. The bend should come either from the hips (like the African women) or from the knees: squatting down to lift a heavy weight or kneeling to make a bed or clean a bath. In the kitchen, work-tops should be high enough to avoid having to stoop forward, and if you have to put heavy dishes on low shelves you should kneel down to do it. Standing at the sink or the stove is a good time to remember the line of gravity running through your body.

Talking is the occasion when bad habits are most likely to happen. How tempting when you are exchanging confidences with a friend to curl up on the sofa in a slumped position. Or, at a difficult interview, to emphasize what you are trying to say with tense shoulders or a poking chin. Or, at a party, to shift your weight from one foot to another as the conversation flags. These are tendencies to watch out for until good body alignment becomes a way of life.

Then there is eating. Nowadays this is quite often done on the move: a snack seized from the refrigerator and eaten standing up or walking about. But if you are sitting at a table (which I infinitely prefer) then, again, your spine should be straight and touching the back of your chair; avoid slumping your body or leaning forward on the table supported by your elbows.

Finally, we come to sleeping. What bliss to get into bed at the end of the day. At last you can lie with your spine extended and the strain on it reduced to a minimum. Make sure that your mattress is firm enough to support you without sagging, but not so hard as to be uncomfortable. Lying flat on your back is the best position of all and very helpful even during the day if you need a rest. Put a small pillow under your head, lie straight on your back, and let your feet and ankles roll slightly outwards so that they are relaxed. (People with bad backs often find it helpful to place a pillow under their slightly bent knees as well.) You will feel the tension and tiredness seeping out of your system and this relaxation will impel you towards sleep.

Having understood the essentials of posture and body alignment and applied them to everyday living, we must now think about how they affect the wearing of clothes.

Most women, when they consider style in dressing, have a mental picture of a tall thin model with a willowy figure who, as they say to themselves, 'can look good in anything'. Fashion photographs show exaggerated postures which are far from correct body alignment but which look daring and attractive. And models, when they parade couturier clothes, adopt an artificial stance, throwing their hips forward above bent knees as they glide down the catwalk. These habits are redeemed by the girls who model sports clothes with free movements and a healthy out-of-doors appearance – which also happens to be the most popular look at the present time. They are the ones to copy.

We have to remember that high fashion, the kind created by the world's leading designers, is almost always exaggerated. It is intended to make a dramatic impact. By the time it reaches the shops it has been scaled down to meet the needs of ordinary women who dress in a practical way for their everyday jobs and lives. Fashion appeal is still there, plus a wide variety of choice. But how the clothes will look when they are actually worn depends to a great extent on the wearer – her figure and her posture.

For example, a hollow back will cause a skirt to crease round the waist and ride up behind. Round shoulders will spoil the line of a jacket, particularly one with shoulder-pads. A slumped posture and a thick waistline will affect the hang of a dress, and a protruding stomach will ruin its silhouette.

Even with good body alignment it is necessary to know what style suits you best. This understanding increases as you go through life, but sometimes there are painful lessons to learn along the way. I remember one that happened when I was nineteen.

I had gone to stay in New York with a most generous American friend of my mother's. The first thing she did was to take me to Bonwit Teller and fit me out with a marvellous evening ensemble. The main ingredient was a long, closely fitting red dress with a halter collar, bare shoulders and a little train! There was ruching round the collar and the train, which one was supposed to kick gracefully to one side before one started to move.

'Do you think I can manage it?' I asked my friend.

'Of course, my dear. Your carriage is perfect for it,' she replied.

She bought me a long red chiffon scarf, which I was to dangle from my wrist, a lipstick to match, and a small evening bag to tuck under my arm.

'Wear it all at my New Year party,' she said.

The evening arrived. I felt very smart, but also rather shy and self-conscious. The American girls were much more sophisticated than I (I was wearing lipstick for the first time). Could I do justice to my beautiful dress? All went well until I was asked to dance. Then, on the dancefloor, carried away by a Fred Astaire tune, I forgot all about a dignified carriage. My partner and I charged up and down the room, turning, twisting, inventing new steps, moving backwards, forwards, sideways. The music stopped. I looked down. There on the floor, nestling against my feet, lay my little train. Ragged and dirty, it had been torn to shreds.

I found out from this experience that for me it was essential to be able to move freely in whatever clothes I chose – an important discovery for my future style.

Part of body alignment is a feeling for rhythm. Rhythm activates all of nature: a wave breaking, a river flowing, wind tossing leaves. There is also the slow internal rhythm of plants growing,

pushing up through the earth, of sap rising, of petals loosening and falling.

In the body, internal rhythms are unconscious but must be unimpeded and active for health to be preserved. The same is true for the outer rhythm of movement. Its flow, which co-ordinates muscles, joints and limbs, should also be unimpeded. If the body is trained in good alignment, a natural feeling for rhythm will develop not only when exercising or dancing but also when engaging in ordinary daily activities like walking, sitting down and getting up again, bending to open a cupboard door, or stretching up to reach something on a high shelf. All these actions can be performed with rhythm. The reverse – jerky or tense movement – makes for strain. It is surprising how much inner relaxation can grow from using rhythm in everyday life.

We each have our own rhythm which dictates the way we move. This is closely related to our body shape. The small vivacious person moves more quickly and decisively than the tall willowy type who glides with grace. Plump people are usually deliberate in movement, thin ones tend to be more staccato. With training in body alignment you can find your own appropriate rhythm.

In fashion too rhythm is important. It is interesting to analyse how many fashion pictures incorporate movement in their presentation. The figure on the page may be striding along with her legs swinging, her hair flying or her skirt flaring out; one arm may be gesturing and her head may be turned sideways. A static picture is not nearly so effective. This subtle sense of movement is an essential factor of style, depending as it does on rhythm as well as on good body alignment.

In the next chapter we shall discuss two other components of style: shape and colour. They deal with outer appearance and ways in which it can be enhanced. But the basic factor to which both relate is good body alignment. Awareness of bad habits of posture and the practice of good ones – when walking, standing, sitting and moving – prepares the foundation to which shape and colour can be applied. And the corresponding improvement in self-confidence, health and figure makes the effort involved well worth while.

2 . SHAPE AND COLOUR

In the last chapter we considered shape from the point of view of correct body alignment and a well-balanced silhouette. Now we must think about individual types of physique and see how they can be made to look their best in the materials and designs which clothe them.

Bodies consist of shapes which are made up of straight and curved lines. Painters like Rubens emphasize the curves. Sculptors like Giacometti elongate the straights. Most people's silhouettes are somewhere between these two extremes, usually inclining more to one than to the other. It is important to know which, so that your clothes can complement your body line. For this purpose, I suggest a candid examination in front of a mirror.

Wearing a leotard, or as little as possible, stand a few feet away from the mirror and look at your silhouette. Is it predominately straight or curved? If you are tall and thin, with slim hips and a small bust, you obviously come into the straight category. If you have rounded hips, a pronounced waist and a full bust, then your outline is curved. But many people are not so easy to define. The broad-shouldered, slim-hipped type may have a full bust. The small neat figure with a straight outline may also possess delicate curves. The categories merge into one another, and unless you are at one extreme or the other you will want to know the main tendency of your silhouette rather than your exact type.

Next, look at your proportions. It has been maintained that the ideal body could be divided into four equal parts: from the crown of the head to the underarm; from the underarm to the division of the legs; from the division of the legs to the knee; and from the knee to the floor.

These are the proportions that our eyes are familiar with from classical sculpture and paintings, although in modern fashion and

modern art they are often distorted. For instance, the long-legged look is admired today, so those whose legs from the knee to the floor are longer than usual can wear very long skirts and also very short ones. Their legs will look out of proportion to the rest of their body, but they will be fashionable nevertheless.

Most of us, however, prefer the evenly proportioned look. It was immortalized by Chanel with suits which have never gone out of fashion because of their practical, easy-to-wear quality. Each of us knows what is the best skirt length for our own legs. But to stick to it stubbornly when skirts drop or rise is to sacrifice style. A little legerdemain is necessary to create the right effect.

If your legs are short from the knee down and long skirts are in fashion, you can shorten your jacket to make your skirt appear longer without having to lose your legs in a too-long skirt. Conversely, you can wear a very short skirt successfully provided your jacket is not too long. If you are the long-legged type and want your legs to look in proportion when wearing a short skirt, you can still achieve that look by wearing your skirt and jacket a little longer.

Small adjustments to skirt and jacket lengths can make all the difference to your silhouette, provided you know clearly what your own proportions are and how to disguise or emphasize them for the effect you want to create.

Once you have determined your body line – straight, curved or somewhere in between – try to accept it gracefully and work with it so that your clothes can enhance it. In youth, most of us go through a phase of wanting desperately to look like someone else. I remember when I was thirteen and had already grown to my present height of 5 feet 7½ inches I resented the fact that I was the tallest in the class and looked enviously at girls who were dainty and petite. Today, I observe my granddaughters accepting their height – they are both taller than I am – but wanting to iron out some of their curves. I tell them they should treasure the rounded silhouette of youth and make the most of it. All too soon it may disappear into overweight middle age or scrawny old age.

To truly accept oneself is the task of a lifetime. But we can all make a start by getting to know our physical type and choosing clothes which are an extension of it and which will enhance our individual style.

In previous ages, one physical shape became the ideal and women had to distort themselves to fit it. We can all remember

photographs of our Victorian grandmothers with their sloping shoulders, tiny waists, rounded arms and smooth hair demurely parted in the middle and falling into pre-arranged curls down each side of the face. What happened to the women with square shoulders and rebellious hair? How much agony of whalebone, curling tongs and tight corsets had to be undergone to create the desired picture?

Fortunately today we have a wide variety of models, each true to her own style. We see them in television advertisements every day. As long as we remember that we are watching an artificial product whose natural attributes have been enhanced by a posse of professionals, they can be instructive to look at as examples of people who have got their style right for what they have to do. This should be our ideal and it is one that *can* be achieved. With thought and practice each of us can find the design, colour, make-up and hairstyle that will enhance our natural attributes and give us the confidence to show them to the best advantage.

So, having decided on your body line and its predominant silhouette, look for this first when choosing your clothes. The pure straight category will include outfits with wide shoulders, narrow straight skirts, clear well-defined lines and bold details. Women tending towards straight but needing a softer line will go for a fuller skirt, a looser fit and a textured material. The frankly curved physique needs round soft lines, curved shoulders, rounded lapels and full skirts. And those close to the curved require the same softness but they can vary it with some straight lines: slightly padded shoulders or a loose jacket hanging to hip length.

These suggestions are only pointers; obviously each of us has to make her own choice. But if you think of a spectrum with severe tailored garments at one end and curved softened ones at the other you will be able to fit into it what is appropriate to your own body line.

Once you have established your physical type in your own mind you will be able to choose clothes which will enhance your good points and disguise your weak ones. This knowledge comes with trial and error, or occasionally from the opinion of candid friends who will tell you – at the risk of displeasing you – when you have made a mistake. Being a tall straight type myself, I now accept that I look best in tailored clothes of a classic style. I have learned how to soften them with perhaps a cowl neckline, the use

of a soft scarf, or the placing of pockets. But it took me a long time to realize that bows or frills were wrong for me and made me uncomfortable however much I tried to accommodate them. They looked so good on the rounded, feminine types that they tempted me.

Weight of material is another important consideration. Again, it needs to be suited to your physical shape. Most fabrics come in different weights – heavy, medium or light – and the clothes you choose will have already been designed in the appropriate weight for their purpose. You must then select what is right for you. Women with small bones and delicate features can wear fine, light fabrics but would be swamped in rougher textures. Those with heavier frames need heavier materials – tweeds, linens, gabardines – to offset their larger bones and stop their bodies from dominating their clothes.

Texture is also important – whether the material is tightly or loosely woven, flat or nubbly, smooth or rough. This can affect the line of the clothes. For a straight sharp line you need tightly woven fabrics or materials with a sheen, such as satin, taffeta, or Thai silk. Curves are best expressed in fabrics that drape well, with soft folds: jersey, silk or wool-and-silk blends. And for those who want to soften a straight line, textured fabrics that are loosely woven will produce a more muted silhouette.

Balance between the wearer's physical shape and the weight and texture of the fabric she wears is what to bear in mind. Some women have a sixth sense in knowing what materials are right for them. Others have to learn the hard way. How many of us have been carried away by a length of tweed in Scotland, a floral cotton in Switzerland or a delectable mohair in Italy or Greece, only to find on returning home that it is quite inappropriate for our needs! In these days of easy travel to places with tempting ethnic clothes one has to keep a tight rein on one's aspirations and remember the essentials of cut, fabric and finish when shopping there.

The same is true when choosing prints. Again, the pattern should be in harmony with the line of the garment and of the body beneath. Curved types can wear soft flower prints, or swirl or scroll designs. A straight figure needs a sharper, more defined geometric pattern – hound's-tooth, herring-bone or checks. And for softening too-straight lines, paisley, tartan or plaid patterns are useful.

Top designers can be trusted to use suitable prints for the line they are creating. The same is often true of the copies of these designs when they reach the High Street shops. But for those who mix and match their garments or make their own clothes, an awareness of the relationship between print patterns and body line is important. Fortunately, most of us incline towards the type of print that will suit us. Choosing it is such an individual affair that advice can only be general. Perhaps attraction is the best guide. More likely than not, you will look good in a print you are really drawn to.

Is all this advice too detailed and cerebral? Does it leave out the fact that you can fall in love with a dress at first sight and *know* that it is right for you without any analysis? The answer is that you can. But perhaps this depends on a set of special circumstances – the time, the place, the inspiration – which cannot be relied upon. You can only be truly thankful when they happen. Most of the time we have to select from the wide choice in the shops and, after that, decide on something to wear each morning. How are we to make it look fresh and interesting as we face another day?

This brings me to the vital topic of accessories. Scarves, gloves, belts, fashion jewellery and hair ornaments can highlight an outfit or redeem it if it is dull. They can also ruin it if they are unsuitable. They take time and experience to collect but are a source of great pleasure when they are exactly right. Sometimes the wrong ones are given to us as presents and then the only thing to do is to discard them ruthlessly. Accessories *must* be expressive of our own taste.

Daring accessories are for the young, who have more time and inclination to experiment with them. They love earrings and necklaces and tend to brush aside the importance of handbags and shoes which they often treat like well-loved old friends. (One of my granddaughters, on a recent trip to London from her college, tramped all over the city and later went out to meet her friends in her climbing boots. She was so fond of them that she could not discard them.) But older women know the great value of handbags and shoes in complementing any outfit. Again, they need to fit in with the general line of the clothes and of the individual.

To go with a straight line, handbags should be square, rectangular or of the envelope type. A curved line needs a rounded bag made of soft leather, or a pouch shape. Handbags

also demand care. They should be cleaned regularly and not stuffed so full that they lose their shape. A handbag is a very personal accessory, often precious to its owner, that helps to create the overall impression of an elegant woman.

Shoes, well-fitting and well-polished, are another essential item. Time was when a man judged a woman's style by her shoes and gloves. Nowadays comfort must be the first consideration, but this need not mean wearing only trainers. Pretty shoes with low heels in every shape and colour are now available in most shops; and to flatter the legs it is often a good idea to match the shoe and stocking colour so that an unbroken line is achieved.

Scarves are marvellous accessories, as they can be worn in so many different ways. Choose a print or design to fit in with your body line. And if you like fashion jewellery, bear the same thought in mind: a square or geometric belt buckle for a straight line; a circle, oval or shell for a curved one; heavy chunky jewellery for a tall person; more delicate, softer pieces for a short one.

Two other important things to mention are cut and finish. Good cut is essential for elegance. It depends initially on the maker but it is also affected by the garment being the right size. This should be in direct relation to your own shape. A well-rounded person will not look thinner by squeezing into a size too small for her. A thin one needs some fullness and looseness in the fitting to counteract her lack of bulk.

Expensive designer clothes are generous with size and material, and are always beautifully cut and finished. They are the ideal to keep in mind when shopping – the reverse of the skimpy, hastily thrown-together garments that one sometimes buys on impulse and then regrets. If you are to be well dressed, your clothes should look as though they are an extension of yourself and not something superimposed on an unwilling body. This means choosing garments of the size which most becomes you, irrespective of the size-tag. Your own appearance should be the guide; sizing can vary greatly with different manufacturers.

A good finish also has to be ensured. Check that enough allowance has been made for seams and buttons, that hem-lines are hanging even, pockets are lying flat, the bottom hem of a jacket is straight, and prints and checks match at all seams.

Much of this advice is probably known to you already and some of it may seem fussy and boring. But the end result is well worth

working for. Knowing your body line and what suits it will be the foundation on which you can build an overall impression of style heightened by your own touches of originality and variety. So much for *shape* as an ingredient of style. Now we come to a different, and for me a more exciting consideration: *colour*.

From an early age colour has meant a great deal to most of us, and this was equally true of our ancestors. Colour is woven into the traditions of the human race. It has come to be identified with certain states: black for mourning, white for purity, purple for royalty, scarlet for pomp. In the liturgy of the church, colours are chosen to commemorate special days. White is worn at Christmas and Easter, purple for Advent and Lent; apostles and martyrs are commemorated on their special days with red vestments. These customs have an ancient lineage.

In modern times political movements have chosen distinctive colours for their symbols – black shirts, red flags, blue rosettes. And colours also carry emotional overtones for which we could each make our own list: red for violence, blue for mysticism, orange for happiness, silver for fantasy, gold for wealth, and – my favourite colour – green for hope.

In childhood, colours are more vivid and real than later. A child loves the painter's primary colours: red, yellow and blue. When light is broken by a prism to create a rainbow, a child is entranced by the violet, magenta, green, orange, yellow and red of its miraculous arc. Perhaps the same is true of nations when they are young. One thinks of the dramatic yellow worn by the early Chinese dynasties and Buddhist monks, and the rich deep reds and blues of Gothic stained-glass windows.

As we grow up we become aware of shades and tones and of a subtle interplay between colours, which we enjoy. But strong colours still affect our emotions. Light unified is white; the absence of light is black. Between these two poles all the gradations of colour exist. To respond to them each day is to add another dimension to living.

The colours to which we are drawn as children and which we instinctively like best are probably the ones which will enhance our personality later. In the world of fashion and beauty a seasonal colour system has been in vogue for some time, which uses the four seasons – spring, summer, autumn and winter – to describe the appearance of four different types of woman with

varying skin tones and hair and eye colouring. Just as each season displays its own harmonious colours so each woman, when she learns to which season her looks belong, can find the colour palette that suits her best.*

It is an ingenious idea and works well, provided it is not too slavishly followed. Rather, it should serve as a basis for selecting a range of colours which are flattering to you. You can either seek a consultation with an expert whose analysis of your looks will establish your seasonal type, or you can work it out for yourself with the aid of a mirror and a colour chart. I have recently attempted this and have found it amusing and instructive. For the benefit of those readers who have not yet discovered their seasonal type and would like to, I append some information.

The seasons are divided into four categories of colours. Winter's colours are cool, vivid and bright, with a blue base. Summer's colours are also cool but with blue, rose or grey undertones and more pastel shades. Colours for spring have clear yellow undertones and are fresh and warm. Those for autumn, both vivid and muted, are based on golden tones with a rich warm feel. Though, with a few exceptions, each palette uses the same colours, there is a great variety of tones. For instance, greens are yellow-green for spring, moss green for autumn, emerald for winter and blue-green for summer. Summer and winter women can wear blue-reds which are cool. Spring and autumn women look better in warm orange-reds.

As well as variety there is intensity of tone. The colours of some seasons (and therefore the colouring of the women they suit) have more depth. Winter and summer are both cool in colour but winter's colours are vivid and clear whereas those of summer are more muted (royal purple for winter, but plum for summer). Autumn and spring are both warm in tone, but spring has only clear colours, bright or delicate, whereas autumn's can be both vivid and muted. The golds, browns, greens and oranges in this range tend to reflect the differences in looks of the spring and autumn women.

What are those differences? In such clearly defined categories there are bound to be overlaps. But allowing for these and for the fact that appearance changes with age, here are the general principles.

* *Colour Me Beautiful* by Carole Jackson (Piatkus Books) contains detailed information and descriptions.

WINTER

This is the largest category and there are more varieties within it than in any of the other three. Skin tones vary considerably, from pure white (like Snow White) to olive-skinned, oriental and black. Skins have a blue undertone; cool clear colours such as chinese blue, shocking pink, fuchsia or bright burgundy make them come alive. Winter women usually have dark hair which tends to go grey prematurely but attractively, until it becomes a silvery white.

Many women in this category have a sallow skin which is easily confused with the golden skin of the autumn group. But autumn shades do not suit winter women who look best in vivid colours. They are the only group which can wear black and pure white to advantage. Their eyes tend to be dark – in the brown, hazel, grey-blue, grey-green or dark blue range. They should avoid colours with golden undertones such as peach, orange, tan or yellow-green and stick to shades which are blue-based or have clear tones like lemon yellow or emerald green.

SUMMER

This category also has a blue undertone to the skin, but with more pink than the winter woman. Complexions vary from very fair and pale to rose-beige or even sallow. The last type benefits greatly from wearing the cool, clear colours of summer. Pinks range from powder pink to deep rose, mauves from lavender to plum, and greens all have a blue base. The overall impression is light and muted.

Summer women, with their soft and rosy look, often have blond hair (which may have been almost white when they were children). This tends to darken in adolescence but will bleach easily in the sun and respond well to highlights or a blond rinse. Brunettes in this category range from light brown to dark brown, usually with an ash tone. The hair of summer women goes grey gradually, turning to soft salt-and-pepper or pearly white, and blending well with their natural colour. Eyes are light blue rather than dark blue, or green, hazel or grey, but rarely a true brown. Like the season, summer women have a pastel look in a variety of tones. Strong dramatic colours are best avoided.

AUTUMN

With autumn we reach the category of warm colours. The skin has a golden undertone: ivory or peach for fair-haired women, golden beige ranging to copper for brunettes. True redheads, with their delicate complexions and freckles, also belong to autumn. Autumn's colours are muted rather than clear, with warm undertones. There are few blues – only kingfisher blue or a deep periwinkle. Greens range from olive to turquoise, which is one of the few clear colours in the palette. Yellow-gold, mustard, rust and peach-apricot are all muted colours; and the reds all have an orange base. In the beige and brown category, oyster white is a most becoming colour and the tones shade down to a dark chocolate brown.

Hair for the autumn woman, whether auburn, dark golden-blond or warm brown, has gold or red highlights. A few are ash blondes and many are redheads. When autumn women go grey the effect is usually harmonious, not a striking contrast as in a winter woman but warm and soft with a golden tone. Eyes are dark brown or golden brown, amber, hazel, green or turquoise (this usually goes with red hair).

The autumn colours of the woods and fields all suit autumn women. They can wear the muted browns, greens and reds of the changing leaves and mirror what is happening in nature outside.

SPRING

Spring colours are also warm, like those of autumn, but they are clearer and brighter. The skin has the same golden undertone but in a lighter shade. Autumn's ivory, peach and golden-beige skin tones are reinforced with pink, and with rosy cheeks which blush easily. Spring colours are bright and delicate, like spring itself – light clear gold, bright golden yellow, peach, coral and clear warm pink. Blues (there are many more blues than for autumn) range from violet to clear bright aquamarine. Greens have a yellow base, beiges and browns a honey one.

Spring women are usually blondes. Their hair darkens as the years go by and some start with hair already brown, or with ash tones. When their hair eventually turns grey it changes to a pale warm dove-grey which later becomes creamy white. Eyes are in

the light range: blue, green, aquamarine or golden brown. The whole effect of the spring woman is bright and delicate like the season itself, subject to swift changes of mood but always clear and lively.

I wonder if you will find it difficult to fit yourself into one of these categories? You will have realized that physical character- istics overlap the seasons and colours intermingle, although depth, shade and tone are distinguishable for each. These factors make it hard to come to a conclusion. As well as looking carefully at your skin tone and colouring, you may have to trust to your intuition. Most people know which colours they like best. They probably also know which season they prefer. You can start there. Preference and instinct are not bad guides.

I found no difficulty in deciding that autumn was my favourite season, and that I felt happiest with autumn colours. Fortunately my appearance fitted in with that choice. For years I chose brown, beige or camel as my basic colours and relieved them with the golds, tans and yellows of autumn and with green or flame- red. Pink was anathema to me and I never wore blue or grey. Then one day a candid friend took me aside.

'I'm so tired of seeing you in those dull browns and beiges,' she said. 'Why don't you try some new colours? Now that your hair is grey you can wear navy and some blues. Try!'

I did. I still liked my golden-based palette but I added colours from the other seasons which had warmth and depth, such as winter's chinese blue, spring's warm grey and summer's deep rose. The grey, matching my hair, was particularly successful. So I learned to experiment with colour without losing the range that suited me.

Colour can also make all the difference between conventional, conservative dressing and a high-fashion look. One has to be careful not to get into a rut in adopting a habitual style which suits one but which can be limiting and unadventurous.

I recently discussed this problem with another candid friend who gave me some food for thought when she said: 'You always look nicely turned out but not really chic. To be chic is different from being suitably dressed.'

This friend has been dressed by top couturiers all her life, so she understands the stamp of high fashion and is able to apply it to her own needs. I reflected on her comments and resolved to be more daring. I started with colour, combining my autumn palette

with a fashion colour of that season. For instance, with my tomato red, terracotta or rust I found I could use navy or burgundy, either as a background or for accessories. I also checked on the length of my skirts (vital for a fashionable look) and thought about the line and size of any new clothes I might buy, bearing in mind the current fashion for an overscale look; this meant choosing jackets and coats a size larger than usual.

Colours can also affect mood. At times we are drawn to a particular colour because it reflects a strong emotion. My elder granddaughter, leaving her much-loved international college and parting from friends who were returning to faraway continents and whom she might never see again, said to me: 'For the last two weeks of term I couldn't wear anything but black. Any other colour seemed completely inappropriate.'

Suiting your colour to your mood *is* important and entails sensitivity and awareness. A colour can emphasize or counteract your mood, lift you out of a depression or plunge you deeper into it.

For example, blue has melancholic as well as cool and serene connotations. Yellow can be sunny and cheerful but also flamboyant and sensational. Grey, which makes you feel peaceful and secure, is sometimes dreary. And pink – soft calm pink – can be obvious and sugary.

Black, the most sophisticated colour of all, is also funereal and depressing. So unless you want to give yourself over entirely to sadness, as my granddaughter did, you might enliven it with tranquil cream or, as a complete contrast, defiant red.

Much of this application of colour to mood comes instinctively; and instinct in this case is a wise guide because, with the outer manifestation of inner happiness or sorrow, you are relieving tension and helping yourself to feel more at peace.

Dressing with style involves taking thought and using application. The consideration we have given to shape, line and colour in this chapter has shown them to be important; understanding them helps when choosing new clothes or combining old ones in an imaginative way.

To be 'in fashion' does not necessarily mean a slavish following of the latest mode. It requires discrimination so that, out of the fashion bag, you pick what will suit you. For the most important thing to remember is that your clothes are an extension of

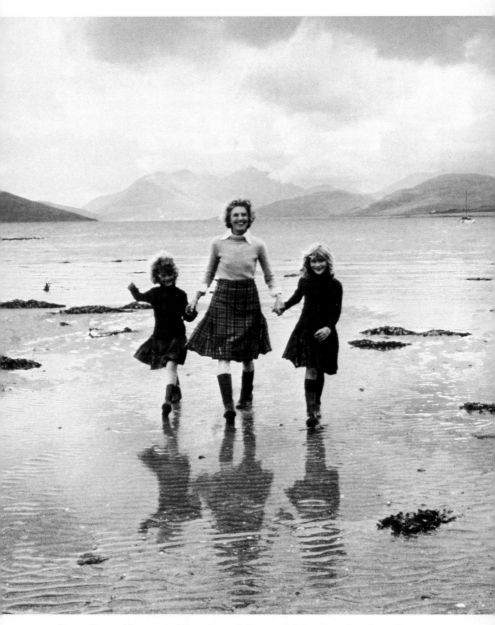

Prunella and her granddaughters Mara and Saba Douglas-Hamilton at their Hebridean home.

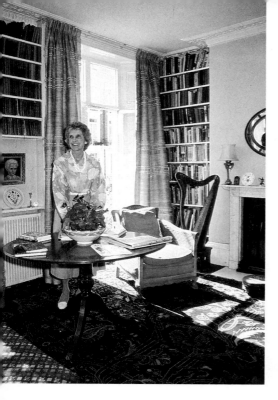

Prunella at home.
(Photograph John Kingdon)

Prunella in her garden.
(Photograph John Kingdon)

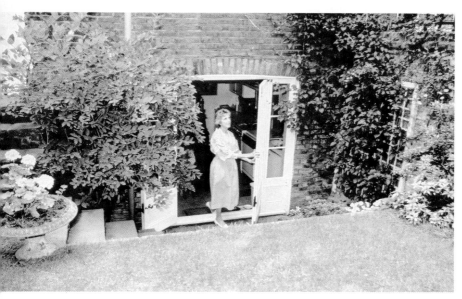

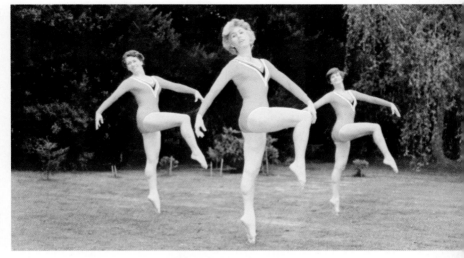

Health and Beauty Exercise teachers. Left to right: Rosemary Barber, Margaret Peggie, Margaret McAllister.

Lucy Martin with a recent class. (Photograph John Kingdon)

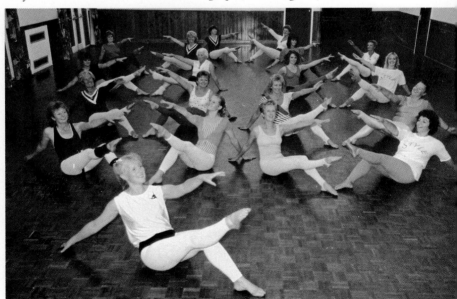

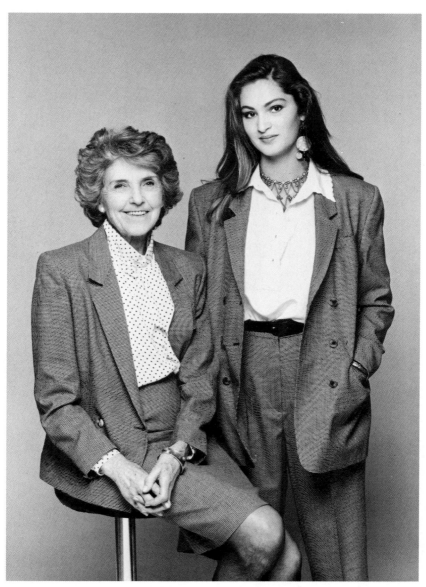

Prunella and her granddaughter Saba. (Photograph Terence Donovan)

yourself and an expression of your personality. Whether the style you favour is a natural, sophisticated, conservative, or adventurous one, knowing about shape and colour will enhance it and will help you to choose what is right for *you*.

3 . APPEARANCE

What impresses you most about a person when you first meet them? Do you look at their eyes, hair, figure, expression or the clothes they are wearing? Do you make up your mind immediately or do you reflect, wonder and revise your initial opinion later?

Certainly, first impressions *are* important, for the exterior of a person often, in some indefinable way, represents what goes on within. We see the outer image, but swiftly and intuitively we connect it with the inner personality. It is wise therefore to let your appearance develop out of your own image of yourself, rather than have it imposed on you by some current vogue or fashion.

> O wad some Pow'r the giftie gie us
> To see oursels as others see us!

None of us fortunately knows exactly what others see, although an unexpected glimpse in a passing mirror may give us a disconcerting idea. But if we heed the poet Burns and make the effort to look at ourselves with candour and humour, that effort will not be wasted.

Let's think first about the foundations of appearance: health and vitality. Good looks depend as much on diet, fresh air and exercise as on daily beauty care. Most of us know which foods to eat and which to avoid; the basis of a healthy diet, one that contains a balance of vitamins, proteins, fats and carbohydrates, is now common knowledge. Within these categories we can select the diet that suits us best, for individual tastes vary and experience will soon show what our own bodies most need.

In western countries most people tend to eat too much. One large meal a day is enough; the others should be small and well balanced. For instance, cereal and fruit for breakfast, salad and

cheese for lunch, a biscuit or two with a cup of tea at tea-time, and then for dinner a two- or three-course meal which can really be enjoyed. No eating betwen meals (bad for health and figure) and plenty of water to drink at all times. Water is a splendid aid to beauty as well as to health, clearing the digestive system and helping the tone of the skin.

A good diet is a habit, like so much else, and I am convinced it can be learned and followed by anyone if the will is there. Having eaten healthy foods all my life and eaten sparingly, I have found that such a diet pays golden dividends as you grow older. This means fresh, clean, appetising food, well cooked and not too much of it. Balance (the ancient Greeks again) and moderation in both eating and drinking are the key words.

Fresh air is a more difficult commodity to command. For those who live in cities where the air is polluted and petrol fumes abound, complexions are bound to suffer. Beauty aids cleanse and protect the skin, but the exhilaration which comes from real fresh air is missing.

We need to make the most of the country or the sun when we get the chance, baring our skins to the elements and storing up the effects of fresh air in our systems. I go each summer (and during the year also when possible) to an island in the Hebrides where rain and wind lash the complexion, but with marvellous results. The beautiful skins, rosy cheeks and clear eyes of the country Irish and country Highlanders are legendary. Looking at them, one understands the benefit of good unpolluted air taken in large doses.

The benefits of sun are more controversial. Psychologically it gives an immense lift to those living in a grey climate, and a moderate amount of it is excellent for looks and morale. But too much exposure to sunlight, apart from other possible health hazards, makes the skin coarse and eventually wrinkled, dries up the natural oils and takes away colour.

I lived for six years in the Cape in South Africa, where the climate is Mediterranean, and there I used regularly to oil my face and hair with coconut or avocado oil (taking a morning off to do it) to counteract the loss of natural oils. I also wore a sun-hat in strong sunshine to avoid burning and freckling my skin. Even greater care has to be taken in tropical countries with an extreme climate.

*

Exercise too is vital for the proper functioning of the body and hence for the appearance. Most of us realize this and feel its tonic effects when we *can* take it, but it is often hard to fit into a busy life, especially for those who live in cities.

Going to an exercise or dance class regularly is one of the best ways. A good teacher at such a class will tone up the whole system by improving the circulation, limbering the joints, and working on body alignment and posture. The result of this concentrated hour's activity will benefit looks and figure as well as health.

Some women maintain that cleaning their houses or trudging round supermarkets is enough exercise for them and they feel disinclined to take any more. Unfortunately such activity tends to be tiring rather than stimulating as the psychological factor of enjoyment is missing. If an exercise or dance class does not appeal, there are alternatives which will produce the same effect. Walking involves the whole body and can be geared to the capacity of the walker, relaxing the mind as well as toning up the whole physique.

Cycling is something many city people do for convenience and speed as well as for exercise. Jogging still has its devotees, although it should be approached with care and proper preparation of foot and leg muscles.

Swimming is a wonderful natural activity and one of the best forms of exercise. It uses all the muscles of the body without the pull of gravity so that they can act with greater freedom and ease. It is also therapeutic for many kinds of disability, especially bad backs, arthritis, or muscular weakness. Swimming requires no apparatus, no teacher and no preparation, and can be kept up for a lifetime.

The important thing is to be convinced of the necessity of exercise. There is such a wide field of choice, including games, that everyone should be able to find something to suit them. Taking exercise need not be dull and a duty. It can become a pleasant habit and a relief from the sedentary lives most of us have to lead.

We now come to the personal details of appearance; hair, body care and make-up. Hair has not been called a woman's glory for nothing; we all know that it can make or mar our looks. Fortunately there are so many hairstyles to choose from today

that each woman can find what best suits her and best expresses her personality.

Daily care is important. I was brought up to brush my hair one hundred times each night. I still do this, though my grand-daughters laugh at me. Brushing stimulates the roots and restores the natural oils. I learned this from an old aunt who, in addition to brushing, used to massage her hair by pulling little pieces away from the scalp and rotating them from side to side with a sharp motion of her thumb and first finger. She did this all over her head each morning and at the age of eighty-nine she still had beautiful thick silvery hair.

I wash my hair once a week, using a light shampoo and a conditioner, but many people wash it much more often, especially those with short 'gamin' hairstyles. They tell me that modern shampoos ensure this does not dry out the oils in the hair.

Hair colouring is something most women come to sooner or later. In Britain, many of us start life with fair hair which darkens as we grow older. Often this natural darkening of the hair suits the complexion, but if you want to keep your former colour a rinse can be effective, provided it is in a shade that complements your natural skin colour. Highlights are also an attractive way of brightening hair and general appearance. I think that an overall dye should be put off for as long as possible. Once committed to it you have to continue and, in spite of all that hairdressers say, it *does* affect the quality of the hair.

I used rinses and highlights until my hair turned completely grey, and then I abandoned them and let nature take its course. This was a great relief. I found that the colour of my hair suited my skin, which had also changed, and I was able to wear clothes in a whole new range of colours. But grey hair needs careful attention. To look smart it must be kept in extra good condition and should be cut in an attractive style.

This is a very important consideration. Like body alignment and colour coding, your hairstyle requires a frank gaze in the mirror. It should complement the shape of your face. If your face is long, thin or rectangular, you will need hair fullness at the sides. If it is round or square you can sweep your hair up or back and leave the sides flat. People with classical features and a good jaw line can wear severe hairstyles. Those whose looks rely more on colouring and expression need a softer style.

Long hair worn loose is lovely on the young but should be firmly discarded once youth is over and it loses its natural glossiness. Shoulder-length hair is more practical and can be adapted to many different styles. If the hair *is* kept long it looks well when swept up or back in a bun. The young can get away with casual untidy hair, but a neat head and a well-defined line are essential as the years pass.

An expert haircut is always a good investment, even more so as you grow older. It is worth keeping abreast of changing hairstyles and adapting the current look to something that suits you. Having thick, naturally curly hair with a pronounced wave on top I have always found it difficult to make my hair do what it doesn't want to do. But good cutting is wonderfully helpful as a basis, and if one occasionally achieves a new style it is a great lift to morale.

Body care, another personal detail of appearance, really entails care of the skin. This means the skin of the whole body, not just the face. We all know about our faces. They *do* get attention. Each day we have to look at them in the mirror – to comb our hair if nothing else. But the skin of the rest of the body, usually hidden by clothes, is often neglected.

This is not so in the natural world where animals spend hours grooming themselves. My younger son, who is a zoologist in Kenya, tells me that elephants have a bath every day, immersing themselves in water up to their necks and rolling in mud afterwards to stimulate their skins. The cat family is equally particular, as any cat lover will know. Cats eschew anything so common as water. They produce the necessary lubricant themselves, and their grooming is a model of industry and application.

My mother believed that the skin was one of the most important parts of the body, helping to regulate its circulation and sensitively reflecting its general condition. She practised what she called 'skin airing' each day, exercising naked in front of an open window so that the pores of her skin could breathe in oxygen and breathe out poisons, and the nerve endings near the skin could be stimulated. I was brought up to do this, and I continue to this day.

There is also a sybaritic side to skin care: anointing oneself with the multitude of creams and lotions which we all see

advertised on television each day. In fact, there *are* essential oils which have a relaxing and beneficial effect on the whole system. Aroma therapy, a massage by a professional using such oils, is a technique which can alleviate stress and bring a wonderful sense of well-being to a tense or strained body.

As well as air, the skin needs moisture. It tends to get dry as one grows older or if one is in ill-health. So it is a good idea to give your whole body a rub each day with a good skin lubricant containing not too much perfume, which has a drying effect. The best time to do this is after a bath, when the skin has been well washed with non-perfumed soap. This simple ritual, performed regularly, will keep the skin in good condition. If it is exposed to extremes of climate, such as strong sun or rough wind, a protective cream and extra anointing should be used.

Cold water is also good for the skin, although a cold bath seems too Spartan a recommendation for most people. But those who are brave enough to bathe in a cold sea (as I do in the Hebrides) will know the wonderfully invigorating effect it has on the skin. Though you may turn lobster-red all over – as happened to a friend of mine after a plunge – it will at least show that your skin has responded to the challenge.

Therein lies the secret. The skin should be sensitive to outer conditions and to the general health of the body. It is the barometer of a person's ease or dis-ease. In a natural environment this happens automatically. But we, in our civilized lives, need to be aware that in seeking to protect the skin, to keep it young and avoid it wrinkling, we must give it room to breathe.

This brings me to make-up. Since earliest times women have painted their faces to improve on nature and adorn themselves, and the subject has a long history of changing fashions behind it. In the thirties, when I was growing up, make-up was already used freely and often more obviously than today, although there were still people who thought it suspect and linked it with Continental morals and forward behaviour. Today such attitudes have largely died out and most people take advantage of artificial aids to beauty, now widely promoted by the media and available in an astonishing variety.

Some, however, still prefer not to use make-up. They like to remain completely natural, showing themselves to others without any artificial help. At the other extreme is the woman

who feels naked without it and cannot face the world until she has painted her face. I notice that the young today use little or no make-up during the day but produce a glamorous personality that spares no artifice when they go out in the evening.

Natural good looks – healthy, sunburned and fit – are currently favoured in the fashion world. They reflect the adventurous, active lives many young people lead. But this image is not for everyone. As one grows older nature can no longer be relied upon to do all the work. Colour fades and lines appear. Judicious make-up can be very helpful then and, if carefully applied, can still look natural. Too much make-up, on the other hand, is ageing.

Not so long ago, with this book in mind, I went to a beauty salon for a lesson in make-up. I left half an hour or so later, having been hustled through a beauty routine by an assistant who repeated advice like a parrot as she plastered my face with paint. At the end of it all, I looked at least ten years older.

What, then, is the best thing to do? Most of my readers may already have a daily make-up routine that suits them. I describe the one I follow in the appendix at the end of this book. But here, briefly, are some of the basic rules.

First, clean the face and neck. Second, moisturize the skin, including the neck. Third, cover any blemishes. Fourth, apply foundation. Fifth, use colour where you feel emphasis is needed. Sixth, dust with powder.

I live in a city most of the time, so my make-up is appropriate for city life; less is needed in the country. In both places I try to achieve a natural effect. Make-up should never be obvious; it must enhance, not obliterate, the face.

At night I remove all make-up (face and neck) with a cleanser and then rub in a good nourishing cream with the tips of my fingers. This is especially important in the country, where the face is more exposed to wind and weather. Keen gardeners like myself often have to sacrifice their hand beauty to the garden, so before I go to bed I use a hand cream which I massage in round the nails where the skin tends to get rough or discoloured.

Once I have applied my make-up and achieved the best result I can, I try to forget all about it. Nothing is worse than a woman who continually gets out her powder compact, re-applies her lipstick or fiddles with her hair.

For me, the finishing touch to make-up is a spray of scent. Some women use the same scent all their lives and are recognized by it; I prefer to vary it according to mood or season. My granddaughters supply me with new bottles of scent and, if I am lucky, other friends or members of my family give me old favourites. If necessary, I buy it for myself. Scent brings such confidence and gives such a lift to the heart that it is something I find essential. It can be used at any time of day to relieve strain and re-charge batteries.

The ingredients of appearance we have considered so far all come under the heading of maintenance. There is another, equally vital yet less under our control: sleep. Each night, early or in the small hours, we surrender to what Edward Thomas in his poem 'Lights Out' called:

> The unfathomable deep
> Forest where all must lose
> Their way, however straight,
> Or winding, soon or late;
> They cannot choose.

Sleep can be taken for granted, neglected, decried as a waste of time, or vainly pursued. But we cannot do without it. Our appearance is bound to suffer. And not only our appearance. Sleep is a natural and wonderful restorative of the tissues of the body, the cells of the brain and the health of the psyche.

In the natural world sleep comes easily at the end of the day. In civilized lives it is harder to achieve. All of us have, at some time, lain wide awake with thoughts racing through our mind and the chimes of the passing hours sounding in grim succession. One way of wooing sleep under these circumstances is to try to completely relax the body. Relaxation of the mind will often follow. Here is a technique well worth using during the day and putting into practice on your bed last thing at night.

Start by lying on your back on the floor – a hard surface is best. Stretch your whole body as in a yawn, arms opening out overhead and feet stretching down until the legs are fully extended. From this tense position relax, bringing your arms to your sides, rolling your feet slightly outwards and feeling the weight of your body sinking heavily into the floor.

Next, draw up the right leg until the knee is bent, keeping the sole of the foot still on the floor. Hold it there for a moment, then let it relax heavily to the ground again. Repeat with the left leg. Feel the whole weight of the legs from the hips downwards. Now clench the right fist and tense the muscles of the arm. Then relax, letting the elbow bend slightly and the fingers part. Repeat with the left arm.

Next, try to loosen each part of your trunk: ribs, shoulder-blades, shoulder-joints, hip-joints. Imagine a heavy sense of gravity pulling them towards the floor. Lastly, keeping the back of your neck stretched, roll your head very slowly and heavily from side to side, like a billiard ball rolling in slow motion on a baize table. Close your eyes, uncrease your forehead, and relax the muscles of your face. Take several long deep breaths, filling your lungs with air and letting your abdomen relax. All active movement will have ebbed from your body and you are now in a state of peaceful physical equilibrium, ready for sleep.

Finally, apart from maintenance, appearance entails presentation and a certain degree of art. This is where it links with style which can also be expressed in many different ways. Let us, for the moment, think of four ways of presenting ourselves, each of which we will certainly have used at some time in our lives: the natural, the dramatic, the classic and the romantic.

The natural style is for the sporting, open-air kind of woman who looks good in casual clothes, likes sportswear (now worn by almost everyone, male or female), appreciates simple jewellery and uses little make-up. For formal occasions this type looks best in a dress or suit of good material which relies for its effect on cut and a plain colour. The natural style has a youthful look and this can be preserved even by older women, although they will need to take more care with their grooming.

The dramatic style is the complete opposite: sophisticated, theatrical, and tending to extremes. A touch of exhibitionism is necessary to carry it off. The dramatic type of woman often dresses in high fashion and is not afraid to experiment with colour, bizarre jewellery, and heightened make-up. She will be conscious of the effect she is creating, having thought it out carefully beforehand, and will enjoy putting it into practice.

The classic style may seem pedestrian and middle-of-the-road, but it is in fact one of the easiest to adhere to. It can make up in

distinction of cut, line and fabric what it loses in originality. Avoiding extremes, it is conscious of the prevailing fashion though not a leader of it. Classic types tend to have tailored clothes of good fabric in a single colour, enlivened by carefully chosen jewellery, a well-groomed hairstyle, and enough make-up to enhance their looks. Older women often veer towards a classic style but it can also be unexpectedly attractive on the young.

The romantic style is in essence for the feminine woman with curves; billowing skirts, frills and ruffles, shawls, and low-cut necklines come to mind. But it can also be expressed by the wistful, 'gamin' type, or by the 'heroine' who conveys adventure through her open-neck shirts, her beautifully cut trousers, and her high boots designed for striding across wide open spaces. Each of these looks is valid and there are many others, for all women feel romantic at some time and can learn to adapt their own particular style to a romantic occasion. The danger to beware of is exaggeration; balance is as necessary for the romantic type as for everyone else.

As in colour coding, the four styles overlap. Your personality, character and outlook will decide which of them is predominantly yours. There will of course be occasions when you want to switch to another. For instance, a classic appearance is suitable for the business or professional woman when she goes to meetings or makes a speech. But the same woman can transform herself into a romantic type for a party, a wedding, or an intimate evening at home. Mood plays an important part and you should allow yourself to be guided by instinct as well as by reason. The vital thing is to feel comfortable and confident in whatever style you adopt. Remember also that changing your style to suit the occasion will be stimulating for yourself as well as for those who have to look at you.

The final, and perhaps the most important ingredient of appearance is expression. When considering body alignment, we agreed that it is not enough to create a beautiful statue; the statue must move. The same can be said of the face. It can be expertly made up to create a harmonious whole, but if it is not animated by the personality of the individual it will be nothing but a mask. In the introductory chapter I suggested that, as you grow older, you get the face you deserve. Developing this further I believe that the lines of your face reflect your predominant

emotions and your enduring qualities. Sadness, strain, dis-satisfaction and anger all show. So do intelligence, courage, compassion and humour. Not least, giving and taking in personal relationships and the creativity that finds outward expression in work, art, house or family, leave their mark and make you unmistakably the person you are, recognized by a face that is far more than the sum of its individual features.

Appearance then is a yardstick of what matters most to its owner and for this reason it is worth giving it some time and thought. This may help you to find new ways of expressing your 'characteristic bearing, demeanour or manner' – the unique gift which you as an individual possess and which you can share with others.

4 . SURROUNDINGS

The famous architect Le Corbusier called houses 'machines for living in'. He designed them with spare, sweeping lines, modern materials and the maximum use of space and light. They were paragons of efficiency. But most women want their houses to be something more than a machine. The feminine instinct for home-making is very strong; so is the desire for self-expression. These two can be combined and find an outlet in conveying one's style to one's house.

Why is it that in some rooms we immediately feel comfortable and at home? They seem to welcome us with a sense of harmony and peace. In others, we become stimulated or entertained by what we see. In still others, we feel uneasy, disconcerted, even repelled. How is it that a room, a place full of inanimate objects, can make such a strong impression, can convince us almost at once that we want to stay in it or would like to leave it as soon as possible?

The answer, surely, is that every room is a reflection of the person who owns it, a vehicle for their taste, outlook and style. There are as many ways of doing up rooms as there are people who inhabit them.

Virginia Woolf, emancipating herself from her father's Victorian influence, longed for a room of her own. Countless other young women have reiterated that cry. The care they once lavished on dressing a doll and then on dressing themselves, progresses to decorating their surroundings and having the freedom to do this in their own way.

Freedom is the key word. Many people, when furnishing their rooms, are inhibited by memories of the home in which they grew up and which they feel they ought to reproduce. Or by recollections of houses owned by their friends and

neighbours. Or by too much advice from professional designers writing in women's magazines. All these are good sources for ideas, but they should not be allowed to interfere with the development of individual taste.

Some women have the flair to visualize exactly how an empty room will look once they have achieved their plans for it. They can enter a dilapidated, run-down house and see its possibilities immediately, drawing on their imagination and experience to produce ideas which will transform it. Not only that; they will then set about the renovation with fervour and enthusiasm.

Other less talented mortals have to learn more slowly. As with choosing clothes, we gradually build up the necessary confidence and experience by a process of trial and error. Experts can be consulted for advice, but often the woman who is going to live in the rooms designed by the experts knows best what her own needs are. Once the basic decisions have been made, time is necessary to build on them. It is far better to camp out in a half-finished house than to be committed to a choice of wallpaper or furnishings made too hurriedly.

Expense is not the only criterion for excellence. Comfort matters, and so do originality and taste. One of the most attractive rooms I can remember was owned by a French pianist friend of mine who lived in Cape Town. She had furnished it with old pieces, picked up in sales, which she had renovated and kept immaculately polished. On the walls were cartoons of French musicians and poets; on the tables, books and music scores. Colour was provided by flowers, a large bowl of fruit, cushions and rugs. A piano stood in one corner, workmanlike and much used. All was permeated by warmth and vitality and had been gathered together with the minimum of expense. Like most artists, she had very little money to spend.

For many people home means traditional furniture, each piece in its accustomed place, in an arrangement which does not change. In old houses where belongings are passed on from one generation to the next, a sense of security is engendered and home becomes a place removed from the trials of the world. T.S. Eliot's description of the dust on a bowl of rose-leaves expresses this feeling. Young people are especially susceptible to this kind of atmosphere and usually dislike changes in their environment.

Recently I did up a semi-basement room in our Chelsea house

which is occupied from time to time by my granddaughters, changing it from a bedroom to a sitting-room where they could entertain their friends. I placed a sofa-bed between the two front windows and hung a large mirror, which would reflect the garden, along the length of the wall opposite. I had the other walls painted white for light and space, and ordered built-in book cases and a desk which runs the whole length of the space below the mirror. Under it are shelves and drawers where papers and homework can be stacked.

When the two girls next came home from school I proudly showed them their new room. Cries of dismay rent the air.

'Where is our lovely big double bed?' they lamented. 'Where have all our posters and pictures gone? How can we do homework looking into a mirror? And why is everything so *tidy*?'

I would have done well to remember the reactions of my two sons when I dared to change anything in the house where they were growing up.

Nevertheless change, including a new arrangement of furniture, is a tonic to a room and to its owner. If nothing else, it reveals dust and cobwebs in corners and behind pictures and may lead to an enthusiastic spring-clean. There is nothing sacrosanct about the way furniture is placed, or sinful about moving it. Our reluctance to do so may stem from the Victorian legacy of a place for everything and everything in its place, in an age when the decoration of one's house was a measure of one's respectability.

If surroundings are never changed they tend to get taken for granted; one is no longer aware of them. Some people, men especially, prefer this. They dislike spring-cleaning and resent any permanent alteration even more. This seems to be a deep-seated instinct. But how sad to allow your home to become a place that is taken for granted and never looked at afresh! Homes need attention and imagination just as your clothes and your appearance do. Even if you have to work your transformation late at night when everyone else is asleep, pluck up the courage to do it.

Moving furniture entails making the best of what you possess. Pieces can be transferred from one room to another; for instance, a bedroom chair taken away from a window may disclose a beautiful view and find a new place in the drawing-room that fits it perfectly. Keeping your eyes open in other people's houses also

helps. Ideas gathered from a lived-in home could be more useful than advice from a magazine.

Comfort and simplicity are good guides; so is the convenience of those who will use the room – seating for easy communication, small tables for people to put things on. And colour, to inspire the room and yourself, can be achieved with cushions, rugs or pictures if you choose a quiet general background. But it is a mistake to play too safe. You will end up with a bland result more like something out of a showroom than a vehicle for your own taste and personality.

What other ways are there to enliven a room? Mirrors are one (in spite of my granddaughters' objections). Not only are they often lovely pieces of furniture in their own right but they also generate light and increase space. One of the traditional places for a mirror is over a mantelpiece, but it can also be hung in a dark corner to introduce extra light or placed to reflect something precious like a picture, a garden or a view. In semi-basement city rooms mirrors are invaluable for giving the illusion of space.

This can be achieved also by clever lighting, one of the most important factors in any room. Needless to say, the best possible use should be made of natural daylight. Windows where sunlight streams in should never be shrouded by heavy curtains, or even, in my opinion, by net ones.

After dark, artificial lighting should be different for different rooms: subtle and unobtrusive for the drawing-room; bright and practical for the kitchen; shaded for the bedroom, but with a good enough bedside light for reading.

If you eat in a kitchen dining-room, as many people do nowadays, candles on the table can be substituted for a bright overhead light once the meal begins. A drawing-room with a centre rose and a cornice is better suited to a centre light, perhaps a chandelier (which can be picked up comparatively cheaply at a sale or a second-hand furniture store). Lamps give a soft, intimate light, and carefully placed spotlights can create a dramatic effect by illuminating some particular object. Strip lighting, concealed and reflecting on to the ceiling, gives a pleasant anonymous light and is good for a large room, although some people now consider it rather dated.

In our Hebridean cottage we have no electricity, only firelight, lamplight and candles. The atmosphere evoked by these on a dark night when a storm is raging outside is unforgettable. In winter,

our Aladdin lamps must be lit by 3.45 p.m. and they remain in use until about 9.45 a.m. the following day. The cosy light they give more than repays the chore of filling and cleaning them. Candles drop wax on clothes and on floors but their illumination is warm and flattering. At night we pad upstairs to bed, each carrying one, and then we read beside a cluster of them until we fall asleep.

Moving into a new house or re-arranging an old one is a very absorbing task and can become quite an obsession. Indeed, for a short while it has to be. The energy needed will not last for ever and things not achieved in the first flush of enthusiasm will probably never get done. In our Chelsea home a naked electric bulb still lights the hall just inside the front door and I have never yet got around to buying a shade for it. But once the house is furnished or the room has been re-arranged, this obsession should be allowed to die. If I feel myself in danger of becoming too house-proud I think of Dylan Thomas's Mrs Ogmore-Pritchard 'in her spruced and scoured, dust-defying bedroom'.

A home must be a haven, a refuge, a peaceful uncomplicated place where you can comfortably relax and put your feet up without worrying too much about damaging the chair covers. If it is simple and practical it will be easy to maintain – an important consideration for working wives and mothers – as well as a vehicle for your taste and style. Homes need love, just as people, animals and flowers do. Old pieces of furniture are like old friends. They have been in this world for longer than we have and will continue in it when we are gone. They thrive on attention.

The same is true of old houses. In London, quite a number are continually changing hands, being bought and sold to new owners within the space of a few years. Each time this happens another wall is knocked down, another room built on. A new spiral staircase is put in; a new bathroom is added. The house is receiving attention, but not always of the right kind. Its fundamental style and quality are being obliterated. Sometimes this ends in catastrophe. The other day, in a street near my home, without any warning a house suddenly collapsed.

Old houses are often at their most beautiful when they are completely empty. Before moving to Chelsea we lived in a Regency house in Sussex. The time came for all the furniture to be moved out and sent to London. At the end of an exhausting

day I stood by the front door and contemplated the denuded house.

I gazed across the circular hall through the open doorway leading to the drawing-room. Its white Greek moulding shone; its arch invited exploration. Beyond stretched the graceful proportions of the room, uncluttered and serene. French windows opened on to the garden. From the hall the wide staircase, guarded by two white columns, swept upwards branching halfway into two curves which disappeared to a remote landing. It was all so familiar, yet suddenly so strange, almost as if the invisible spirit of the house was becoming manifest. In the sadness of parting that reflection comforted me.

It has returned to itself, I thought. Its beauty will outlive whoever might occupy it again.

If you think of your house as a living entity you will find that it co-operates with you, disclosing possibilities that were at first unseen. For example, a family home requires space for each member of the family and as the children grow older it must express their needs. Sometimes it is possible to build on a room for them or convert an already existing one which will allow for the differing tastes and occupations of the different generations. But it is important also that the whole family is able to come together at some time to have a meal, converse, or entertain their joint friends. In many houses the kitchen dining-room is where this takes place.

The kitchen has to be practical but it needs a warm, homely atmosphere as well. Modern kitchens have acquired efficiency and labour-saving devices but often at a price. They tend to be standardized and commercialized and their units sell for an exorbitant amount. The woman who gives thought and imagination to her kitchen and puts it together herself rather than buying a stereotyped arrangement will create a room with more individuality and style.

As we go through life our living-space tends to expand. Most young girls begin with one room, their bedroom. Later, when they enter their working lives, they move into 'a room of their own' (Virginia Woolf's desire), which offers them scope for expressing their own style. But life is usually too full and busy for this to happen. The room remains no more than a background for many other activities. And often it is exchanged for a flat shared

with others, a difficult environment in which to exercise individual taste.

The next stage is permanent living quarters. The career woman may settle for her own apartment, financed by her own efforts and thus doubly precious. Here she can relax and find an outlet for creative talents often submerged in a stressful job.

The girl who marries and starts raising children needs a house or flat which will contain her family; this will swiftly become all-absorbing. She and her partner stand in their empty rooms looking at good and bad points and reflecting on how to use or disguise them in the best possible way. They decorate; they place unwelcome furniture or wedding presents not to their taste in tactful corners; and then they set about acquiring the things they really like.

After children arrive the house has to expand, and imagination has to be used to exploit it to the best advantage. Gone are the days of intimate personal identification. The parents' taste can still be maintained, strengthened by experience, but now it has to take on a collective quality that can be enjoyed by a number of other people. The house has reached its full capacity.

Later on, it retracts again, and in a sense returns to the original couple. It has mellowed, perhaps grown shabbier, but it has also matured. And now they can make it truly their own, expressive of their distinctive taste and style.

Surroundings, of course, do not matter to everyone. Many people are indifferent to them. Or so they say, though I have noticed that these same indifferent people often respond well to a warm and comfortable room with a friendly atmosphere. But for those to whom style is a part of living, the places they inhabit are of great importance. At work, in the home, or at leisure, they feel the need for their personalities to make some impact on their surroundings, even if only in small ways. A vase of flowers on the office desk; a poster in the student's study; a photograph in the impersonal hotel bedroom: all these are assertions of individuality. Sometimes surroundings respond to these efforts and the atmosphere changes; at other times individual style is overwhelmed.

This happens out of doors where one's surroundings are entirely beyond one's control. The immediate environment may be distasteful (a run-down dirty city street) or inspiring (a beautiful country view); in either case they will affect you while you have no effect on them.

On holiday, we choose the kind of environment – mountains or sea or countryside – which will make us happy and to which we can relate. But how are we to preserve this source of strength when we return to our daily working life? In my experience, there is one excellent way: a garden. Nowhere can the sense of harmony between a person and their environment be better expressed. (And here I include window-boxes, tubs, indoor plants and the other expedients to which city dwellers have to resort.)

A garden is a man-made space, the result of someone's effort to tame nature. From Eden onwards it has been seen as a place of refuge and delight. This is well expressed by a famous late-medieval picture of the Cologne school depicting a Paradise Garden where the Virgin and her Child sit among flowers, in the open, but enclosed by a protective fence which shuts out the clamorous world. The figures and the garden reflect each other, each bringing their own peace and harmony to the scene.

During the course of my life I have had a variety of gardens, each of them different. When I lived in South Africa I had a garden situated among vineyards in Constantia, just outside Cape Town. A green lawn, constantly watered with sprinklers, swept down to a little valley; beyond rose Devil's Peak, part of the Table Mountain massif, an incredible backdrop for any garden. There were beds of canna lilies, lemon and pomegranate trees, figs and avocados, and a sweet-smelling ginger plant which scented the whole house when I brought a spray indoors.

Geraniums spilled over the walls, never damaged by frost (there was none), and vygies – African rock-plants with brilliant petals – made splashes of colour all the year round. We had a verandah shaded by an orange bignonia creeper and I used to sit there and watch the weaver birds darting in and out of their conical nests. The abundance of the garden delighted me, but the garden boy did all the work. So, although I walked in it and cut flowers from it, I never established the bond of digger, planter, and pruner which brings garden and owner close together.

My next garden was in Sussex. A large one of two acres, it had lawns and sturdy English trees – lime, chestnut, oak and beech. Daffodils ringed the trunks of the trees and a stretch of uncut meadow held wild flowers all summer. There were rose-beds, shrubberies, and a little pool with water-lilies; and at the end of the meadow stood a copse where pussy-willow buds shone in

spring and a maple glowed in autumn. I deeply loved the garden's beauty but the attention I gave to it was sporadic. I regarded it as my husband's responsibility. I made a rock-garden and planted geraniums in urns on the patio; but otherwise, beyond 'talking to the flowers', I did little else to assist their growth.

My present garden is the small one that is attached to our Chelsea home. This is truly my own. My husband, exhausted by maintaining the Sussex garden, handed the London one over to me. When we moved in, there was a concrete yard in front of the house and another behind. We took out the concrete and in its place made two small lawns, bordered by flower beds. For the back garden, a friend designed stone steps which wind down among flower beds to the french windows of the semi-basement kitchen. There were already three vines growing up a high wall and we kept these, otherwise planting the whole garden afresh. We brought roses, philadelphus, pieris and hydrangeas from our Sussex garden and put in a peach tree, espaliered against one wall. The beds in front of the kitchen got no sun, so I experimented with what would grow there and found that small azaleas, supplemented by impatiens in the summer, did best.

In front, we planted an albertine rose which climbed up the house, and trained another (belonging to the garden next door) along the railings bordering the street. In the flower bed below it are more roses, and geraniums fill two tubs in front of the main door and grow in window-boxes elsewhere.

A little city garden has to be kept immaculate. This entails a surprising amount of work, including dealing with pests in a running battle which seems much fiercer in the town than in the country. But it is wonderfully rewarding. For three years, blackbirds have nested in our honeysuckle. In June, I wake to the scent of roses drifting in through the bedroom window. And the first daffodils, resolutely turning their faces away from the house, gladden the passers-by. It is this contrast between the garden and the busy streets around it which constitutes its greatest charm.

If no garden is possible, a window-box is a good substitute. London abounds in these; on the first and second floors of houses as well as at street level. Each window-box reflects the taste of its owner: abundant, sparse, obvious or imaginative. Observing them, one realizes that line, colour and shape, the basic ingredients of style, apply to window-boxes as well as clothes.

Indoor plants are another way of enlivening one's surroundings, and these days there is a great variety to choose from: plain green leaves in many different shapes and textures; bowls of bulbs flowering in early spring; pots of azaleas or hydrangeas which can later be transferred to the garden. They do require care but not necessarily the magic green fingers that used to be considered essential. In my experience, anyone can learn to tend indoor plants and find, in the process, an absorbing contact with growing things.

We have thought about different types of surroundings and agreed that they should be an expression of their owner's taste and style. But how can a busy woman – a mother of a family or the holder of a demanding job, or both – find the time to attend to them? I think this depends largely on how important she feels her surroundings to be.

Fortunately, furniture, carpets and curtains are not living entities like children, animals or plants. They can survive without much attention for a number of days, provided the essentials are taken care of. So in a crisis, or at a very busy time, a woman can discriminate between the priorities in her house and deal only with the most important ones. But equally vital, and much more enjoyable, is the taking of an occasional fresh look which will bring new life to your surroundings: a change in the arrangement of pictures or a dusting of books on their shelves, which may disclose forgotten treasures. Houses also respond magically to occasional gifts: a new cushion, a small rug, a picture or even a utilitarian object for the kitchen which will make life easier there.

Like all relationships, the one we have with our surroundings demands thought and imagination. We need continually to see them with fresh eyes. When we return from a holiday we welcome being back in our familiar environment but are often struck by changes that would improve it. This is the attitude to cultivate all the year round; the one which confirms and perpetuates style.

PART TWO

The Practice of Style

5 . THE THIRTIES AND FORTIES

In my introduction we considered some of the qualities which go towards the making of style. Now I want to see how these qualities can be preserved in the practical tasks of everyday life which occupy so much of our time. Let's start by thinking of the decade when a woman is in her thirties.

Thirty is a wonderful age to be. That is how I felt at the time and how I still feel, forty years later. And I think many women would agree with me. In her thirties a woman still has her youthful *joie de vivre*, fuelled by an adventurous spirit which welcomes challenges, new experiences and new relationships. Her looks are often at their best and her body, even when subjected to the test of childbirth, is still strong and healthy. She has reached a level of confidence she can enjoy.

When I was thirty I think I took all this for granted; it is only in looking back that I realize the worth of those years. Unfortunately, for me they were clouded by two great losses: that of my first husband who was killed in action with the Royal Air Force in 1944, just after my thirtieth birthday; and that of my second husband who lost his life in a climbing accident on Table Mountain seven years later.

My two small sons were four years and two years old when their father, my first husband, died. Although often parted by the war he and I had largely shared the first years of our children's lives and every woman will know how important that is. The establishment of a new little family – father, mother and child – is an ideal start. Yet in 1944 there were many one-parent families, as there are today. So I understand the difficulties of bringing up children without a father.

As well as a time of growth and expansion, the thirties are also a time of increased pressure for a woman, often with a marriage,

children, a home, and a job to look after. In previous ages middle-class women were confined to their homes, where they produced a large number of children and then tended and reared them, usually with considerable help. Their creative activities were mainly restricted to embellishing their houses and influencing their families.

Today 48 per cent of mothers with dependent children go out to work, and though this is often for financial reasons it is also because of a desire for personal freedom and independence. Equality of the sexes is recognized in law, yet an overwhelming amount of work in the home is still done by women: over 90 per cent of food preparation, cooking, washing and ironing, according to a 1986 survey.

We all know that young children need constant attention, and the value of a close relationship between mother and child in the early years is now well understood. Some women give up their jobs and devote their time to their children until they reach nursery-school age. But even so, there is still a great deal to be done, as there is at successive later stages.

In this situation, can an image of style help? I am sure that the answer is Yes. To do the best for your family you must cultivate the best in yourself and keep it intact before their eyes. If this seems arrogant or impossible, think of the alternative: the housewife who stands in her messy kitchen overwhelmed by her work; the mother who is constantly irritable with her children; the wife who blames her husband for her own frustrations. These states are the result of undue stress. The domestic grind can be unbearable unless you preserve some space for yourself, some moments alone when your own talents can blossom and your own style can be reasserted. That style may have to be adapted to your responsibilities, but it must be preserved.

My children were both born during the war but I was fortunate to be able to bring them up in the country. There I could supplement food shortages with fresh milk, home-grown vegetables, plenty of fruit and salads, and extra cheese rations in lieu of meat – a sensible diet for pregnant mothers and young children. I was also lucky to have both my babies at home, or rather in my mother-in-law's spacious house which had a special 'birth-room', used by her daughters and daughters-in-law for the arrival of her many grandchildren. She sat with me throughout

the hours of my eldest son's birth (on the day in 1940 when France fell), while I practised the breathing exercises and the relaxation I had learned during pregnancy. A doctor was also in attendance, and though it was a long labour I felt completely confident of the outcome.

This was probably because I had prepared myself for childbirth during the previous nine months, rather like an athlete who goes into training for a sporting event. The Natural Childbirth Trust was then in process of being formed and I followed their methods. I also practised the exercises from my mother's system which I knew would be beneficial and spent some time each day learning to relax completely. This proved to be the most valuable technique of all. When it came to labour it enabled me to almost drop off to sleep for the precious minutes between pains and to think of their cycle as a rhythm (like a wave breaking on a shore) which worked up to a crescendo and then died away again, giving me a few moments' respite. After a while I was able to relax at the time of the pains as well.

Learning about the physiological changes in the body during pregnancy, and its muscle action during labour, gave me the confidence to co-operate as fully as I could, banishing fears and panic. For the very last stage of labour I had a little chloroform, administered in small doses, but I was conscious of all that was going on and was able immediately after the birth to experience the thrill of holding my baby and welcoming it into the world – an action so ancient, yet to each mother so new.

The opposite to the natural childbirth I experienced is the modern high-tech labour with epidural anaesthesia which eliminates pain but can make a forceps delivery more likely. This can be reassuring to those who fear pain or complications, but it is not always available; only a quarter of British hospitals have a 24-hour on-demand epidural service.

For those women who choose to delay becoming pregnant until their late thirties or early forties, the regular ante-natal monitoring now generally available is very reassuring. Screening tests can detect abnormalities early on; if these cannot be dealt with the mother can be given the option of terminating her pregnancy with the hope that she will try again and next time produce a normal, healthy child.

Today fewer than 1 per cent of women have their babies at home although 10 to 15 per cent would like to. The Government's

view is that women should be encouraged to give birth in larger and properly staffed consultant units of district general hospitals, where the whole range of obstetric, paediatric and supporting services is available if needed. This gives prospective mothers a sense of security, although shortages of midwives and nurses may mean that they are left alone for long periods during the initial stages of labour.

One way of ensuring that you get the kind of labour you would like is to fill in a birth-plan before you go into hospital, stating your preferences in advance. A written birth-plan is now standard in many hospitals. Natural Childbirth Trust methods, or their equivalent, are available in many wards, and sometimes it is also possible to have the midwife who has cared for you during your pregnancy on hand to help deliver the baby. Antenatal classes will have taught you what to expect and how to cope with it, and your husband will most probably be with you throughout the birth – something unheard of in my time. My younger son was present at the birth of both his daughters, an experience he is unlikely to forget.

In the end, the advent of your baby is very much your own personal affair. If you have trained for it and looked forward to it with hope and optimism you will want to see the birth carried out according to your own choice. So it is worth considering the alternatives carefully, and then letting your choice emphasize your personal outlook and style.

In the post-natal period the body is making different and less demanding adjustments than during pregnancy. Now is the time when a careful regime of diet and exercise before the birth really pays off. I found that my figure quickly returned to normal, and after eleven days I was able to go through an advanced exercise sequence quite easily. This has also been the experience of many Health and Beauty Exercise teachers and members, for the body training they learn is designed specifically to encourage safe and successful childbirth.

Keeping a good posture throughout pregnancy is also very important and is much easier to maintain if it has been practised beforehand. Many women, when carrying their babies, tend to over-arch their backs and allow their abdomens to sag. This may appear comfortable but it puts undue strain on the abdominal and back muscles. An upright posture, with the head erect and the correct pelvic tilt, both looks and feels better. The stomach is

then held firmly in position by muscles which are functioning in good alignment. Though you may resemble a ship in full sail, you won't mind because the larger you grow the better you will feel and your good posture will have been preserved.

Post-natal exercises help greatly in getting back into trim (you'll find some in the appendix); breast-feeding is another natural way of doing this and also of having close contact with your baby.

I fed my first son for nine months and my second for six. It was wartime and I was living in the country, with work in abeyance for the time being and my husband away in the RAF. Today, with houses to run single-handed and jobs waiting to be resumed, many women would find such dedication for so long difficult.

Nevertheless, it is still worth starting your baby off on the breast, even if only for a short while. Both you and the baby will benefit physically, and psychologically the time you spend peacefully together will be precious to you then and in the years to come.

Having a career today is no bar to also having a marriage and family. But the first few months of a baby's life are so important that taking time off from work makes the transition to motherhood much easier. If you are a new mother you will be learning the ropes and building up a structure of baby-care. If you already have children you will be coping with them as well as fitting the new arrival into the family. This will almost certainly involve emotional stress for you, your husband and your children. Your role as mother is to be there as support and safety-valve, giving reassurance if there are feelings of exclusion or jealousy, and bringing a sense of humour to daily life.

You have to try to find the right balance between fulfilling the needs of your family and maintaining your own interests and style. Family first often means self last. Keeping appointments with *yourself*, firmly giving up time each day to resting or reading or listening to music or whatever else you find relaxing and refreshing, pays dividends in good temper and puts domestic strains and duties back into perspective.

In the same way, arranging for occasional help, either paid or from relatives, so that you can leave the house and do something to stimulate your mind is also immensely refreshing. Sometimes new babies are so absorbing that they shut out all else. But it is

better for you and for your baby if you don't entirely give up your former life.

I have seen examples of how to keep this balance among young women who had their babies while taking their two-year part-time training as Health and Beauty Exercise teachers. Most of them continued with the course until a few weeks before birth. Afterwards they returned within a month or two and found that the training helped them to regain their normal health and figure swiftly, as well as giving them a valued break from domesticity. When they attended the training days they had to arrange for help at home and usually husbands stepped in to fill the gap. Family support was very important, but given this they could complete the course, surprising husbands and children on their diploma day with the high standard they had achieved. (Incidentally, on several occasions young women who had been trying to conceive a baby for several years unexpectedly did so during the first year of the training.)

For women who work full time, regular and reliable domestic help is essential. A job can only flourish if the mother is certain of the quality of the person who is taking her place in looking after her family.

It's hard to give up your baby to someone else, but if you are committed to a career, or financially dependant on a job, it has to be done. There are plenty of examples of devoted nannies who have been the mainstay of family life; in fact, their regular daily routines may suit small children better than inexperienced or haphazard care.

You have to make a choice, and that choice must suit your finances, temperament and capabilities. You will go on being *you* whether you are the mother of many children or the possessor of a brilliant career, or both. It's important to keep your individuality and your personal style intact, whatever the claims on you. Only then can you avoid being overwhelmed by the circumstances of a busy life.

Whether or not you are balancing the demands of family and career, the thirties and forties will almost certainly be a time of strong emotional attachments, stronger perhaps because time no longer appears to be a limitless possession. Many women today wait until their thirties to marry. By that time they are on their way to success in their jobs or careers but feel the need of

permanent companionship and of a home and family. Few escape strong personal relationships at this stage, whether in marriage or outside it. But these can bring heartache and disappointment as well as elation and fulfilment.

Timing is of the essence. It is hazardous for two people to expect that they will be able to develop at the same rate. One may race ahead while the other struggles to keep up; one may reach conclusions swiftly while the other needs time to reflect. An important part of the art of living is to be sensitive to your partner's inner timing and to try to adjust your own if necessary. A close personal relationship also means having the courage to be honest. The other is not always wrong! You have to try to learn – if possible together, if not, alone – how to change aspects of yourself (not always the other) and how to grow in understanding.

These are some of the problems of permanent relationships. Some women opt for careers instead, where they have the freedom to experiment with new ideas and new people. They launch out on their own and develop independently. This provides a challenge but also carries a corresponding insecurity; for most people, whether they admit it or not, feel that to share their life with someone else is usually to enrich it. Nevertheless, an absorbing career is certainly an antidote to too much heartache and introspection, and it suits many women very well.

A job entails daily attendance. However you are feeling, it has to be done and you have to be there to meet its demands. This is often a salutary discipline. At its best, work can be very fulfilling, encouraging creative talents and stretching you to limits you did not know you possessed. So women who settle for a career often find satisfactions as great as those with homes and families.

Homes and families, however, do not necessarily offer women a permanent alternative to work, especially today when one in three marriages ends in divorce. The inner resources necessary to face this ordeal, or the even worse one of the death of your partner, can be strengthened in some degree by the responsibilities offered by a career.

In my own case, with the deaths of two husbands within the first six years of my thirties, I found the return to my work with Health and Beauty Exercise (then the Women's League of Health and Beauty) immensely consoling. It brought me into contact with other women in the community in which I lived, helped me to share their problems, and gave me an outlet for positive

creative activity. I became Principal of the Bagot Stack College in London, and there I helped to train girls who would make the League's work their career, thus bringing increased health and well-being to thousands of women throughout Britain. In this work, I found great satisfaction.

I knew by then that the thirties decade is one of great pressure in all spheres (including biological). But I felt, too, that the effort to come to terms with it did not mean that I could control all my choices. Chance always plays a part. The ability to seize opportunities when they present themselves and while you still have the energy to make the most of them is vital. Fortunately in many areas of life there are also second chances.

By the time you have reached forty, the years of experiment will be shading into the years of achievement, and during the next decade you will probably be busier than ever. A woman with a career may well be in sight of its apex, with a demanding workload and ever-growing responsibilities. If she also has a family she will have to plan her days carefully. Her husband will probably be facing similar challenges in his work and will need attention and an ear for his problems. And her children will be growing up: no longer dependent, loving, obedient little appendages but strident teenagers. The metamorphoses they go through at this stage vary. Some families can absorb their adolescents without much trouble and share some of their new interests. Others are disrupted by criticism, hostility to existing boundaries and rejection of any standards other than those of the teenagers themselves.

Patience and humour seem to be the only antidotes. This is the time to preserve your own style but also to resist imposing it on your teenage daughter who is desperately trying to find a style for herself. She may pass through several outrageous stages in the process, but underneath the green hair and shocking T-shirt she may need your guidance as much as ever – if you choose the right moment to give it.

Having sons and no daughters I did not suffer this dilemma at first hand. I found that boys' energy is likely to be directed to more perilous outdoor pursuits than to appearance. But then my two granddaughters came along and in the fullness of time they also turned into teenagers. In their case, with my relationship at one remove and no final responsibility for them, the situation

was much easier. I could be less emotionally involved and was able to view their adolescence objectively.

Maturity, of course, exacts a price. The forties are also the threshold of middle age. The lithe figure that was taken for granted in youth is beginning to thicken. Lines of experience are starting to show on the face (not that these matter, provided the predominant expression is a pleasant one). The first grey hairs are appearing. While these are all signposts towards maturity, they also signal the end of youth. So now is the time to give added thought to your appearance.

In my experience, no one need lose their figure in middle age. A sensible regime of diet and exercise can preserve it if the will is there. A busy life imposes rushed meals and no time to keep fit or think about your looks. Yet five minutes of daily exercises and a daily remembrance of good posture can help to halt a figure decline (a suggested routine is given in the appendix). If you can also attend an hour's exercise class each week this will reinforce your resolve and achieve quicker results.

Those who put on weight easily must be firm at this point about a diet of healthy foods – no chocolate or cream cakes and no tempting little snacks to cheer you up between meals. Sensible eating swiftly becomes a habit and improves your health as well as your figure.

Much harder to face are the blows of life for which there are no easy remedies. One problem which now seems to occur all too often in the forties decade is the break-up of a marriage and of the family home. There are no words of comfort for this ordeal or for the unhappy period which precedes it. Adjusting to life alone after a shared existence is hard. It demands all the resources at one's command until hope for the future gradually re-asserts itself and children adjust to a new life with one parent or a shared life with both. The concept of a personal style (something which may have been submerged in an unhappy marriage) does help here because it gives a sense of identity and continuity and a renewal of confidence.

I spent all of my forties as a widow, bringing up my two sons and working at the same time. I tried to keep the holiday periods free by doing most of my work during term time, and I divided home and work responsibilities so that they were as separate as possible. It was an active and rewarding decade though often a lonely one: friends, children and work could not really

make up for the gap at the centre of my life. Then, when I was forty-nine, with one son having left Oxford and the other still there, I married again. And that marriage has lasted until the present day.

This good fortune comes the way of a number of women who are alone after a marriage ends. But only, I believe, if they have been able to make a positive and forward-looking life for themselves first. Often nowadays a second marriage entails a second family and a period of adjustment between the two sets of children. The mother, at the centre of it all, may find herself busier than ever. But it is a constructive kind of busyness, and many women make a brilliant success of it. They preserve their own sense of style and this influences the new regime.

Such then are the hazards, opportunities and rewards of the thirties and forties. These two decades are likely to contain some of the best, busiest, and most challenging years of our lives. They are also a preparation for what is to come, for separating time into ten- or twenty-year spans is at best an artificial device. A lifetime is indivisible; the same person travels through all the decades. The thirties and forties give us a store of experience: happy, sad, enlivening, diminishing. If they also prepare us to make better sense of what happens later, they will have served us well.

6 . THE FIFTIES AND SIXTIES

The forties slip inexorably into the fifties and it is only when the first day of the new decade dawns that we realize middle age is now well and truly here. Few of us will live to be a hundred, so more than half of life has gone.

Such disquieting reflections do not often upset us, for the fifties, like the forties, are generally full and active years with little time left over to ponder where they are leading. But standing on the brink of the decade we may have qualms about what lies ahead. In fact, the middle years of life have much to offer provided we accept them for what they are, not yearning for youth or fearing old age but living in the rewarding present.

I started my fiftieth year newly married to a husband four years younger than myself. My younger son, then aged twenty-two, was still at university and constantly brought friends to the house and to our holiday home in the Hebrides. So I was surrounded by young people and I found it needed little effort on my part to preserve a young outlook. In my work I was also involved with the young – training students to be Health and Beauty Exercise teachers and taking classes for all ages, including one for girls at a domestic science college – so I was able to keep in touch with their thoughts and feelings.

Many fifty-year-old women find themselves in the same position, and this greatly helps to bridge the gap between youth and middle age. The relationship with their families is changing. Children have grown up and put the difficult years of adolescence behind them. They have turned into interesting communicating adults, who can be treated as friends and enjoyed as companions provided always that their independence is respected.

Some of course have grown away from their homes and are leading their own lives completely. They may seem to take their

parents for granted, intent as they are on their own development. When the responsibility for one's children comes to an end it often leaves a large gap in the household, and for a woman the feeling of being no longer needed. Yet if a strong link has been established, this is only stretched, not broken. Time and life will restore it and gradually the roles of responsibility between parents and children will be reversed.

That is for the future. For the present, a mother in her fifties must still be available in a crisis or for special counsel, but at last she has more time for herself.

She needs it. If she is working, her job has probably increased in importance and responsibility. Women with a career are living out its most demanding years. Talent and vitality are still undiminished, and to these is added experience, that most valuable commodity which only time can enrich. A woman in her fifties has much to give to her work provided she maintains her health and confidence.

These depend as much on her mental attitude as on her physical state. Mind and body are closely linked and it is now widely recognized that inner conflict can lead to physical ailments.

In middle age, as in adolescence, emotions tend to fluctuate and sometimes become exaggerated. Slights and humiliations are imagined, tempers grow short, and the usual optimistic, positive outlook wanes. This may be connected with the onset of the menopause, a time when the changes taking place in a woman's body are as significant as those of puberty.

These changes may produce physical symptoms which are disquieting but can often be treated medically. One of these treatments is hormone replacement therapy (HRT); this is now widely used and has helpful short-term results, although the longer-term effects cannot yet be fully assessed.

My feeling and experience are that, if mind and body have been life-long partners in a positive outlook and healthy life-style, the changes of the menopause can be taken in their stride. Of course it is a landmark. To know that one can no longer produce a child means that youth is definitely over. But if one has already reared a family one is content to move on. If, instead, one has concentrated one's powers in work or in some form of creativity, one should now be reaching a point of fulfilment. And as long as the mind remains positive and alert, barring illness the body will co-operate and respond in the same way.

The menopause is a natural function. If mind and body are friends they can experience it together, not exaggerating its effects but regarding it as part of the process of life which will continue (with many more changes) on its destined way.

One of the latent fears of the menopause is that it will alter one's physical response to sex and that this important aspect of life will no longer play a part in one's future. Again, if mind and body co-operate naturally this is much less likely to happen. Anxiety can produce physical symptoms of withdrawal. The reverse – an open, welcoming attitude to loving, and confidence in one's body – will preserve the ability to respond to and enjoy sex for as long as fate allows.

There is no need to take it for granted that in middle age your looks and physique are going to deteriorate. Many women are at their best at this time, more certain of their style and determined to preserve a supple, active body. It all depends on an attitude of mind and a resolve never to give up.

Most people put on some weight at this point but, as I showed in the previous chapter, this can be controlled by regular exercise and diet, and compensated for by good posture, a graceful stance and a walk which has retained its freedom of movement. If you have already trained the muscles of your abdomen and shoulders you will not develop a sagging tummy or a round back. But if you see any signs of these appearing, practise the relevant exercises (shown in the appendix). It is never too late to start!

Now is the time when your style comes into its own. An older woman has the confidence and experience to rely on the style she has built up over the years, both in her personal appearance and her surroundings. She is no longer experimenting – she *knows* what suits her and how to look her best. This means that she can adapt her style to maturity without losing her youthful outlook.

For instance, her hair may turn grey but if it is well cut and styled it can give her a new distinction. Her face will be more lined but, given proper care, it need not dry up into a mass of wrinkles. And her clothes, chosen with the experience of half a lifetime, can be effortlessly suitable for each occasion. Now is the time to try a new look, remembering that the discrimination gained over the years should stop you from making any bad mistakes.

Joining a new activity is often a first step towards this. I know many women in their fifties who have joined a Health and Beauty

Exercise class for the first time and have learned how to use their body constructively and improve their figure. If they have taken their physique for granted during most of their lives it is very interesting for them to find out what the body needs in the way of joint loosening, muscle training and co-ordination. The exercises are fun to do; other women are also trying them; a fellow feeling builds up and friends are made. Women who attend regularly get to know one another well and through their mutual interest in improving their health and figure a kind of support group is established.

This is also true of other activities. The splendid opportunities offered by local education authority classes, day or evening, can be taken advantage of. When I stopped being Principal of the Bagot Stack College (which trained Health and Beauty teachers at Morley College, in London) I enrolled for courses in philosophy, English literature, and poetry, held at the same venue. The philosophy helped me to think more clearly (very necessary); the poetry strengthened a lifelong interest; and the diploma in English literature for which I studied taught me skills of structure and criticism and gave me the desire to try to write something myself.

For me, middle age seemed a good time to extend my horizons. I realized that as people grow older they often tend to retract; to give up some activities, cut down on others, and build a defensive wall around their accustomed habits. Yet nothing is more ageing than habit, excluding as it usually does all spontaneity and originality. The young in heart have to be ready, when the time is right, to discard habit and open their minds to new people and new experiences. If these are of value they can be carried forward into the years to come.

'In the middle of the journey of our life I came to myself in a dark wood where the straight way was lost.' So said the poet Dante in his *Divine Comedy*, completed in 1321, just before his death. Almost 700 years later, at the end of the twentieth century, is this still a valid image for middle age? I think it is, for the middle years are a watershed from which we can emerge treading the right or the wrong path.

The straight way, the obvious way, the known way, is behind us. Youth, with its clarity and conviction, is over; old age lies ahead. Only by 'coming to ourselves' can we realize that new

directions must be found: and 'coming to ourselves' means looking at our lives as objectively as possible and reflecting on how we respond to outer stimuli and demands.

Dante sought a guide in Virgil, the philosopher, poet and man of reason, who was to conduct him through the *Inferno* and the *Purgatorio* – all the circles of human experience – until he reached the *Paradiso*. Horrified, seared, and exalted in turn, Dante learned that he was only one of many rather than the centre of his world. The human situation held everyone in thrall.

To find one's way out of the dark wood one must recall that many others have been there before. And that some spark of creativity – in relationships, in work, in one's home – is one of the best ways out.

To create something one has to draw on inner resources, to concentrate, and to forget frustrations or irritations (the brambles of the dark wood) except for those connected with what one is doing. There is conflict in creating but it is a positive, absorbing conflict, not a negative, depressing one.

I had always been fortunate in having creative work to do but in my early fifties I decided to try something new: I embarked on writing a book. I drafted out the structure of a novel and wrote a few chapters. They were so bad that when I showed them to my eldest son all he could do was refrain from comment!

After that, I scrapped the synopsis of the novel and attempted an autobiography instead. It seemed rather vain and conceited to write about myself, but my life's experience was the only material I had, and I knew I could also include my mother's work and the development of the Women's League of Health and Beauty which she founded.

At the end of two years I completed the first draft and showed it to a literary friend. He suggested that I should revise the point of view from which I had written and slant it more towards how I felt at my present age. I took his advice and re-wrote the whole book. There were three more drafts, taking another three years, before I could present it to a publisher. Several times during that period I felt, as I had many times on a difficult rock climb, 'If I ever complete this, which seems unlikely, I will never, never do it again!'

Finally it was finished. I sent it to an editor friend at Collins, the publishers, who showed it to Sir William Collins. He accepted it and telephoned to tell me so. I could not believe my luck! The

book was published when I was fifty-eight. Much of it had been written in the early morning between 6.30 and 8.30 a.m. – the only time in the day when I could be sure of complete peace.

I tell this story by way of encouragement. I was fortunate to be published, but even if one's writing never sees the light of day, it is still worth doing. Keeping a journal is a good start: it is something which needs concentration and discipline and helps to evaluate experience. The danger is that in describing an experience it may become crystallized in one particular form, so that ever after it is impossible to remember it in any other way.

To a certain extent writing *does* falsify by including only some facets of a situation, discarding others, and using discrimination about what to reveal. But that is true of all art; the artist's task is to convey his inner vision. As this is always subjective and involves him in choice, the way in which it is expressed can vary (like the many different versions Cézanne painted of his beloved Montagne Sainte-Victoire) while the essence remains the same.

Writing can also be therapeutic, as I discovered when my first husband returned from commanding a Spitfire squadron in Malta during the war and spent his leave setting down an account of the Malta air battles of 1942, later published in *Blackwood's Magazine*. His effort to record clearly what had happened put his personal experience into perspective and gave him a greater understanding of it. Above all, writing is another expression of one's personal style, which can be worked on all one's life.

Virginia Woolf wrote an entry in her journal each day, as well as countless letters, while working on her current novel – all with deceptive ease. She was a professional writer; women who are not have to fit their writing into lives which have other pressing demands. But to leave some space for creative activity (and there are many besides writing) is a wise rule at any time of life, and especially during the fifties when a pattern can be established which will endure.

During this decade it is probable that one's children will marry. Whom they choose is their own affair: one is fortunate if their choice accords with one's own, resigned if it does not. In any event they will need support, even though this may have to be unobtrusive. The fact that the family has expanded and now

includes another home emphasizes the passing of the years. It is also a reminder that one must be ready to take second place.

My eldest son, a physicist living in America, married there in 1967 when I was fifty-three. My younger one, an ecologist who was studying elephants in Africa, met the girl of his choice a few years later and they produced my first grandchild in 1970. This was the beginning of a new and wholly delightful era which still continues.

Some women deplore the advent of grandchildren. They fear that this will age them, or that the babies might become an added responsibility. For my part, I found that grandchildren are one of the best things that can happen during one's fifties and sixties. Being with them keeps one young in heart and increases one's hope for the future.

I was fortunate to see a great deal of my two granddaughters. Their parents live in Kenya, so I visited them there and they also came to Britain for holidays from an early age. Later they went to school and college here, filled our house with their friends, instructed me in the latest make-up and pop tunes, and generally 'smartened the old girl up'!

Having had only sons myself, it was a particular pleasure to see how girls develop and to watch each of them assume her individual style. Now, at eighteen and nineteen, they are grown up and we meet on a different level. I hope our close relationship will continue, adapting itself to changing circumstances. And I will not soon forget their lessons in style!

The full and active fifties give way to the sixties which, in theory, should provide a calmer existence. This is the official decade of retirement. But today the frontiers of age are receding and many people are working for much longer than the statutory retirement age. It seems pointless to give up an interesting and valuable activity just because a certain date has been passed on the calendar.

In the sixties you should be able to continue your job or your career for as long as you want to, provided your health and energy hold out. We see many examples of women doing their best work during this decade; in fact the busier you become the less likely you are to fall prey to depression, boredom or apathy.

In Health and Beauty Exercise both teachers and members seem to go on for ever! They have benefited so much from the

lifelong training of their bodies that they cannot envisage wanting to stop. Though some of them during this decade may choose to teach or attend less strenuous classes specially designed for senior citizens, the majority still fit happily into mixed-age groups, and a number continue exercising into their seventies and eighties.

The foundations for this success are laid during the sixties. It is very important then to establish a satisfactory exercise-and-diet routine. However young in heart you may feel, the body does undergo physical changes. Joints stiffen, muscles weaken and becomes less elastic, circulation starts to slow down, and one tires more easily. Regular exercise is one way of counteracting this natural development. Another is a careful, healthy diet.

Eating the right food becomes more important as you grow older because the body no longer possesses the same recuperative powers and inbuilt energy as in youth. Natural foods, as always, are best. But these have to be sought out and consciously included in your diet, a task which takes more time and trouble than relying on fast food and processed food, both of which are tempting and easily available.

Freshness is one important criterion. The vitamin value of fresh fruit and green vegtables declines rapidly; so the freshest specimens should be chosen and they should be eaten as soon as possible after they have been bought. Frozen vegetables and fruit, processed immediately after picking, *do* retain a large percentage of their value but raw fruit and vegetables are best of all. When cooked, their vitamin value is reduced (although less so if they are steamed or cooked in the minimum quantity of fast-boiling water).

Wholemeal bread and wholemeal flour, pasta and cereals will give you energy and some of the protein you need; so will brown rice, which is much better than the processed kind. Cheese, liver and fish are other good sources of protein and necessary for body repair; oily fish such as herring or mackerel also help to stabilize the cholesterol level in the blood.

Sugary foods produce quick energy (very necessary for the young) but put on weight for older women; so the intake of sweets, cakes, biscuits and puddings should be limited or excluded altogether. Natural honey can be substituted for white sugar and taken in tea or coffee, and nuts and raisins eaten instead of chocolate.

Your fat intake has to be carefully watched. Skimmed or semi-skimmed milk helps to reduce it, as does the substitution of low-fat cooking oil, spreads and cheeses for butter and cream. Fresh fruit juices are healthier than the sweet soft drinks which the young consume and then work off in energy, but which fatten their mothers and grandmothers. Apart from figure problems, becoming overweight entails a health hazard by imposing strain on the heart and the general posture. It is easier to deal with this tendency as soon as it appears; prevention is the best cure.

Nowadays, stress is another common enemy to watch. It is a very real danger to people of every age but harder to cope with as we grow older. Much of it stems from the unnatural way of living which modern civilization imposes and which has to be continually countered. But some of it is self-induced.

At the peak of a busy career, or at the centre of a demanding family, stress takes on an obvious form: nervous strain and constant tiredness because there is too little time to fulfil all that we think is expected of us. A day's complete relaxation (ideas for this will be found in the appendix), a change of scene, or – best of all – a holiday, will usually build up reserves of energy to put this right.

But as we grow older stress is more likely to manifest itself in long-term anxiety. The body feels more vulnerable because it has lost some of its former vitality and cannot risk getting over-tired or over-strained. It says 'stop'. The mind finds it harder to accept new ideas and new experiences, and instead of expanding, it contracts. Small things take on undue importance. Punctuality or tidiness become an obsession. Life begins to crystallize into a set pattern, and the more one tries to exclude anxiety from it the firmer a hold it takes.

One reason for this may be that the years seem to be slipping away fast and the future appears more uncertain. Another is that, with retirement from work or release from the demands of a family that is now independent, a gap opens in one's life; and if that gap is not filled constructively, anxiety may swiftly step in.

Retirement means adjustment. This applies to both men and women, married or single, but perhaps most to the married woman whose husband is now at home all day. Fortunately a number of men, if they have been used to a busy life, take on tasks in their local community when they retire, or continue

some of their work part time or in a consultative capacity. Nevertheless, they are around a great deal more than before; they need attention and their presence has to be considered.

This is the time for the married woman to review her own pursuits and to decide which are worth holding on to and which she can now let go (rather like going through her wardrobe and discarding clothes she no longer wears). If some things are given up there will be more space for others, and some of the new activities can be shared ones.

In this fresh life together a sense of give and take has to develop. If this is achieved, it may disclose to each partner a different aspect of the other, and lead to a deeper mutual understanding. This kind of experience can banish anxiety because the gap has been filled. Nor need it be confined to married couples. Friendships have more chance to blossom in a climate of leisure. New activities may bring new friends and time to cultivate them.

With the end of work comes a sense of release. The time is ripe for expansion further afield. The wider world awaits, offering opportunities for new growth; opportunities also for helping others.

In his *Four Quartets*, the poet T.S. Eliot wrote that 'old men should be explorers'. In their sixties, not yet old, women equally can be.

7 . RETIREMENT AND BEYOND

We have considered retirement briefly in the previous chapter because for many people this comes about some time in their sixties, often coinciding with the age at which their pension is due. Exactly when to retire is obviously an individual matter which will depend on many factors, both personal and external.

For those who have worked hard all their lives supporting themselves or their families, retirement may come as a blessed relief. For others, who are giving up a lifelong career or occupation, it can be as testing an experience as puberty or the menopause. No physical changes are involved, but the mental and psychological ones call for a whole new set of responses when a way of life that was formerly taken for granted becomes fundamentally different. For yet others, retirement deteriorates into disappointment. Hopes were too high; the reality brings boredom and discontent. Perhaps the luckiest ones are those who never completely retire but keep up some work or creative activity which absorbs them until the end.

Given health and an optimistic outlook, the seventies can still be a time of discovery and fulfilment. In my own case, the early years of this decade have brought me as much work as ever; also satisfaction, because plans laid carefully in my sixties are now coming to fruition. I begin to be able to take a more objective view of my work, handing some of it over to younger people who can do it quite as well, if not better. This reward (one which many teachers know) of pupils excelling, is something very satisfying.

I find it important still to keep in touch with the young, and above all to be active in mind and body. 'Movement is Life', the motto of Health and Beauty Exercise, continues to be my inspiration. This means keeping the mind open to new ideas and the body fit.

*

Growing old is something we all have to accept. It can be done unwillingly, with bitterness and regret for the passing years; resignedly, making the best of a bad job; or positively, realizing its inevitability but recognizing also its advantages. The last attitude – the positive one – is the best way to preserve style in one's seventies and eighties. These are the decades when some of the qualities of style which we considered in the Introduction, will come into their own.

There is, for instance, the capacity for attention to detail. During a woman's busiest years, when the pressing need is to get things done, this often has to take second place. Now the perfectionist, who likes to do one job beautifully while neglecting others if necessary, will at last have time at her disposal. She can choose what she wants to concentrate on and complete it to her satisfaction.

Retirement also gives you leisure to appreciate your surroundings. Details which had to be skimped before can now be properly attended to. It becomes a pleasure to dust precious objects or rearrange them without an eye on the clock. And hours out of doors, tending plants and watching them grow, will bring you close to the unhurried rhythms of nature and reinforce your sense of time to spare.

A second quality of style which you now have the opportunity to exercise is discrimination. By the time you are in your seventies your tastes and preferences will be well established. You no longer need to sit through a play or television programme which you do not enjoy. The daily bombardment of ideas and advice from the media can be ignored. You are free to choose what you like because one advantage of growing old is that at last you can be truly yourself.

We have all known older people who are described as characters. This usually means that they are forthright, eccentric and original. Through much of our lives we have had to curb these qualities because of politeness, responsibility or thought for others. But in our seventies and eighties, if we want to, we can let them have their head.

Another quality of style which is important to remember is variety. A daily routine is comforting for older people but it should not deteriorate into dullness. It's desirable that each day should have a structure and unfold according to a plan, but the

plan can be flexible. Everyone, young or old, occasionally needs a new enthusiasm to respond to or the challenge of a fresh task to accomplish. Flexibility provides the space for these.

In a busy working life one tends to get through one's household tasks as quickly as possible. Later, with more time at one's disposal, one can give them more attention. Trying out new recipes, shopping for them and then cooking them, is a good way of varying meals. Recently I spent a short holiday in Provence and came back determined to cook only French dishes. This involved careful shopping and a new *rapprochement* with my butcher. My enthusiasm led to a series of delicious dinners over which I took great pains. They lasted for about a week: then my husband asked for a traditional English meal and I suffered from a *crise de foie* due to the richness of the food. But we *had* varied our diet!

The element of comfort which food provides often becomes more pronounced as you grow older. With less to do, food assumes a larger place in your life. But your diet still needs to be well balanced. With the right intake of protein, minerals and vitamins, and a limited consumption of fats, you will give your body the nourishment it needs to keep you fit and active.

By the time we are in our seventies we will know our physical weak points. Rather than give in to them, it is important to guard against the kind of strain that will exacerbate them. When the tell-tale signs appear – whether shortness of breath, aching joints, headaches, undue tiredness, or depression – it is best to try to tackle them at their source.

If you get colds easily, at the first sign of a sore throat gargle with an antiseptic, keep really warm, and go to bed that night with a hot lemon drink after a hot bath. Headaches are often a sign of strain, but they can also mean a digestive upset. Look at your diet carefully and eat sparingly until you have recovered, cutting out milk, butter and other fats.

Aching joints and muscles can mean rheumatism or arthritis. Both these conditions may improve with a healthy diet. When painful symptoms appear, forego alcohol (especially wine) and coffee (hardest of all for me!) and rub a menthol-and-wintergreen lotion on the afflicted places, or put a hot bottle there and *rest*. Once the muscles are in spasm they should not be exercised (although at other times exercise will keep the joints moving and

the muscles in good tone). Take a short rest, with the feet up, and the pain will be eased. Use the same treatment for back pain – one of the commonest disabilities of middle-aged and elderly people – but also check on your posture, which could easily be the cause.

Undue tiredness may simply mean that you are doing too much. But if it persists and is not remedied by a good night's sleep, or a change of activity or environment, consult your doctor. A loss of vitality should never be neglected. You may simply need a medical booster – perhaps a vitamin B injection which the doctor will be able to recommend – or this may be a warning that something more serious is happening.

Depression, one of the worst afflictions at any time of life, tends to occur more frequently in one's later years. It can be very debilitating and is unlikely to disappear through an act of will-power. If the symptoms are severe and persist, you should seek medical help. Talking helps, especially if it identifies some of the underlying causes (for example, a long-standing inner conflict, or a painful or disturbing event from the past which you have been unable to face and have buried away in your unconscious). Stress can precipitate depression and, in the elderly, it is often linked with loneliness and isolation.

A mildly depressed person can be greatly helped by others – the reason why a social group of some kind is so important. It relieves tension and self-absorption and makes people turn outwards, away from themselves. All the options already mentioned – exercise, diet, outside interests, creative activity – are antidotes to depression, and if they can be practised at the outset the slough of despond is less likely to take hold. But the only sure cure is to face the condition steadily, acknowledge it, and take conscious and patient steps to remedy it, realizing that no stigma need be attached to it. Depression, like sadness and pain, is one of the natural conditions of human beings.

Minor disabilities may turn into major ones. Let us hope they will not; if they are tackled swiftly at the outset there is less likelihood of this. But the important thing is to try to banish fear about what *may* happen. Anxiety is the worst killer of all. Many elderly people are beset by it, their lives made a misery by dwelling on the terrible things that may occur. In contrast, a positive attitude to the future is a real life-saver. It can literally extend one's span of years and help one to enjoy what lies to hand

now in the precious passing moment, the only moment of time which is truly ours to control.

If one accepts the limits of retirement one need no longer strive to be competitive or to keep up with one's neighbours. There will also be new benefits. For instance, senior citizens (that dignified euphemism) are eligible for reduced fares on railways and other forms of transport, as well as reduced entry to theatres, cinemas, museums and art galleries. This makes it possible to travel round the city and view what it has to offer at little cost.

The only other group so favoured are students; and indeed the elderly can now become students once again, taking up and studying subjects which interested them but for which they had insufficient time, and visiting places which they have always wanted to see.

This happened to me in the year that I was seventy. I was born in India and had always longed to return there and visit my birthplace – a hill station in the Himalayas. This seemed an unlikely dream. Then the need for research for my third book – a biography of my mother – suddenly made it possible, indeed imperative, and one day I found myself standing on the crest of a foothill in the Himalayas gazing across valleys, gorges and chasms to the eternal snows! An entirely new world opened itself to me. Indian history, religion, philosophy, architecture and landscape took on a new significance and I realized that however long the years ahead might be they would be too short for me to learn all that I wanted to know about this great continent. A similar enthusiasm has, of course, inspired many other senior citizens when they stood for the first time in a place of which they had always dreamed.

To take advantage of these opportunities requires resolve and the courage to launch out into the unknown when it may be easier to stay at home and follow a well-known routine. Financial considerations are also, of course, a deciding factor; but often not the chief one. A lack of confidence and a fear of the unfamiliar may be a more subtle and insidious deterrent. Yet the more we can take advantage of the years when we are physically able to travel and absorb new experiences, the better. A reserve of interest and knowledge is then built up on which we can draw if we become less mobile and adventurous in the future.

Holidays need not necessarily mean costly trips abroad. Many

beautiful places exist in Britain and can be reached without too much expense. Bus tours are available, with special reduced prices for the elderly; caravans are another means of finding secluded beauty spots; and for the active, a leisurely walking tour is still the most rewarding method of all for getting to know and appreciate the countryside.

The key to the enjoyment of all this is to be fit. I have stressed throughout this book that exercise is an important ingredient of fitness. It is also something that you can continue with into old age. Yoga, Medau, Keep-Fit and Health and Beauty Exercise all hold classes for senior citizens. So does EXTEND (Exercise Training for the Elderly and Disabled) whose work is also taught in clinics, hospitals and day centres. (A class of this type is described in the appendix.)

Pat Rowlandson, a Health and Beauty Exercise teacher of fifty years' experience, recently presented a TV series slanted towards the elderly. In the book which accompanied this she wrote: 'To see old friends and colleagues now in their seventies and eighties, with one or two even in their nineties, still fit and able to move with grace and comparative ease, maintaining a good degree of independence, is a heartening and satisfying experience.'*

Classes of this kind can be joined by older women who want to exercise for the first time as well as those who have attended regularly for years. The advantage of a tried system of body training is that you can adapt it to all ages. The class community swiftly becomes a source of friendship and strength, caring for and helping its members if one of them has to face the ordeal of illness or suffers the kind of loss inevitable with age. In these days of scattered families and one-person households such support is invaluable.

The years pass quickly in the seventies and eighties. Families disperse. Friends grow old; they need our care and sustenance, just as we need theirs. Worst of all, those we love die – perhaps a lifelong partner who is irreplaceable. Bereavement is one of the hardest things to face during these decades.

To lose someone we love deeply can happen at any time in life, but as we grow older it happens more frequently and the loss

* *Easy Does It!* by Lesley Hilton (Macdonald Optima)

seems harder to bear. Not only do dear friends go, but often one's husband also; most women live longer than their men. This reality is part of life, something one has always known was likely to occur. But when it does, it is still a severe crisis, a swathe cutting across one's life which will alter it completely. In a long-standing marriage each person has complemented the other for so many years that the one who is left feels naked.

Loss is grievous, but it need not be diminishing. A period of support immediately afterwards is a great help if it can be arranged, and it is usually wiser not to change the immediate environment too drastically for some time. Precious household goods can be comforting and give a sense of continuity in a state of sorrow. Death is always a shock, even when expected. If at all possible, the one who is left needs to be preserved from further shocks for a while and given time to mourn and adjust.

Each person has to find their own way of facing this trial. Although at first memories of shared experiences with the one who has gone may seem too poignant to bear, as time passes they become a source of comfort and strength. And for those who possess a living religion there will still be meaning in their lives.

The three major bereavements I suffered when I was young made me realize that death is a part of life, and that it can strike at any time or in any place. Coming to terms with death gives one a greater appreciation of life; one realizes just how precious it is. But once the dark wing has brushed against one's side it is very hard to recover an unmitigated sense of joy.

Can the concept of style help in the crisis of bereavement? If it is taken in its widest sense – a source of strength for living – I think it can. It will enable you to maintain a standard of behaviour, for the temptation is strong, when you lose a beloved person, to neglect yourself. 'What does it matter now how I look, or what I wear? There is no one to care.'

With death and loss one is brought up against the great imponderables of life and forced to face unanswered questions. Matters of looks seem trivial in comparison. But to build a new life and be able still to find enjoyment and creative activity, some hard self-discipline must be found. Maintaining style is part of that process.

If the loss comes during one's seventies one might be tempted to think, 'I won't be here for much longer, so I will comfort myself

by living in the past and not concern myself with the future.' Yet life expectancy today stretches well beyond the seventies. The eighties and after can still be rewarding decades. Those engaged in creative tasks or pursuing the life of the mind often have an impressive record of longevity.

There are many inspiring examples of octogenarians who have continued to work and be fully engaged until the end of their days. In the world of style there was Coco Chanel, the famous Parisian dress designer. She retired in 1938 but made a brilliant come-back in 1954, when she was seventy-one, and from then onwards ran her Paris salon as the acknowledged arbiter of style and fashion until she died in 1971, aged eighty-eight. Marion Hart, the aviator, is another example. She learned to fly in 1945, when she was fifty-four years old. After completing five thousand hours of flying, she achieved a solo transatlantic flight in a single-engined plane in 1975, at the age of eighty-four. Dame Ninette de Valois, inspiring dancer, founder of the Royal Ballet and choreographer of many memorable works, celebrated her ninetieth birthday in 1988 and is still giving guidance and encouragement to dancers in Britain today.

It must be hard for people of great creative ability to accept its extinction. One is reminded of Dylan Thomas's lines:

> Do not go gentle into that good night,
> Old age should burn and rave at close of day;
> Rage, rage against the dying of the light.

Producing inspiring works perhaps justifies such an attitude on the part of their creators. Yet old age is of necessity a stripping process. Perhaps it can be viewed not as a diminishment but as a return to a state of simplicity. Inessentials are pared away and space is left for wisdom and spiritual growth. This was the view of the poet Yeats who wrote:

> An aged man is but a paltry thing,
> A tattered coat upon a stick, unless
> Soul clap its hands and sing, and louder sing
> For every tatter in its mortal dress.

The final decades are the ultimate test of a life and also of an individual's concept of style. If that has gone deep enough it will survive the losses of age and not be overcome by them.

We often talk of the second childhood of an old person. This may

mean a failing in sight, hearing or understanding, or in the ability to look after oneself – a sad but often inevitable plight. But it can also mean a return to the innocence and wonder of the child; a sloughing off of the self-made persona with which one has faced the world and a shining forth of the true self, free at last to express itself without the fetters of necessity. We have all known old people who have achieved this state and shared the peace it brings with those around them. For them, style has been fulfilled.

We have reached the end of our journey and the end of this book. In the appendix which follows you will find descriptions of some important exercises, more detailed advice on beauty care, a routine for relieving stress by relaxation, a description of a day-centre class, some useful addresses and a list of books which have helped me and I hope might help you. Finding one's style for life is an ambitious undertaking. If in each other's company we have gone some way towards discovering what this involves, then my task in compiling these pages will have been rewarded.

Appendix

BODY TRAINING

Abdominal Exercises

A flat abdomen and a strong back are what every woman would like to possess. This entails keeping the muscles of the abdomen in good tone and strengthening the muscles of the back. The abdominal wall is like a natural girdle which is designed to support the organs inside the abdominal cavity. Proper training uses both the horizontal and the oblique strands of muscle which compose it. This is the only region of the body not supported by bones, and the one most at risk from overweight, poor posture, or deteriorating physical condition.

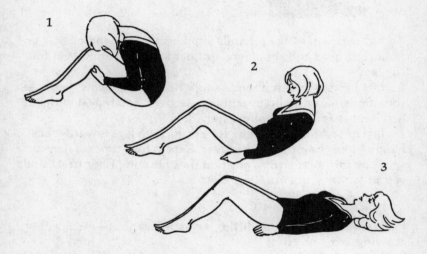

1 Sitting with knees bent, body curled forward and hands under thighs, pull in and up with the abdominal muscles. (Fig. 1)
2 Uncurl spine and lower half-way to floor and recover, then nearly down to floor and recover. (Fig. 2)
3 Uncurl spine all the way to floor and lie with spine flat and knees bent. (Fig. 3)

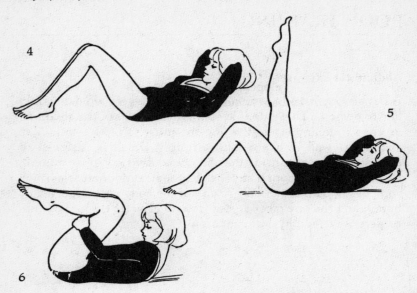

4 Lie with knees bent, hands supporting neck and elbows on floor. Lift head and shoulders off floor and recover. Repeat four times. (Fig. 4)

5 Lift head as before (hands supporting neck, elbows out). At the same time straighten right leg. Recover, and repeat with left leg. Repeat four times alternately. (Fig. 5)

6 Lift head, and at the same time bring both legs towards chest, hands supporting thighs. Recover. Repeat four times. Then curl spine up into first sitting position (head leaving floor first), and repeat whole sequence. (Fig. 6)

Progress 1, 2 and 3 by lifting arms forward at knee level or crossing arms on chest.

Perform 4, 5 and 6 smoothly without straining. The final curl up can be assisted by hands pressing the floor if necessary.

Back Exercises

The muscles of the back also need training to balance the abdominals and to counteract too strong or too tight hip flexors (which join your pelvis and spine to your thigh bones). These muscles, if over-developed, result in a hollow back, causing strain and pain in the lumbar region, a condition which afflicts up to 80 per cent of people. Practise the spine loosening exercises before proceeding to other back exercises which will strengthen and tone the muscles and relieve back fatigue.

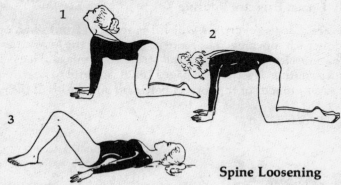

Spine Loosening

1 Kneel with weight evenly divided between hands and knees. Hollow base of spine and lift head. (Fig. 1)
2 Arch spine, drawing abdominal muscles inwards, and drop head. Repeat eight times. (Fig. 2)
3 Lie with knees bent. Hollow base of spine, then press whole spine into floor. Repeat eight times. (Fig. 3)

Back Strengthening

4 Lie face downwards with arms at shoulder-level and palms on floor. Raise arms and shoulders slightly off floor, keeping head in line, and recover. Repeat four times. (Fig. 4)

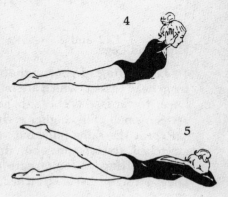

5 Lie face downwards with forehead on hands, palms to floor. Lift alternate legs from hips, keeping knees straight. Repeat eight times. (Fig. 5)

6 Lie face downwards
with hands under shoul-
ders. Raise body off floor,
straightening elbows as far
as possible without strain,
keeping head in line. Re-
cover. Repeat four times.
(Fig. 6)

6

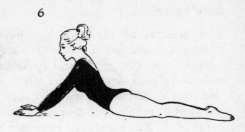

Daily Dozen Exercise Routine

Here are a dozen exercises which I practise in front of an open
window each morning. They aim at loosening the joints, toning
up the muscles and gaining a full stretch of arms and legs. The
posture routine described on pages 18/20 is useful to go through
first as a reminder of the correct pelvic tilt and the lift of the ribs.

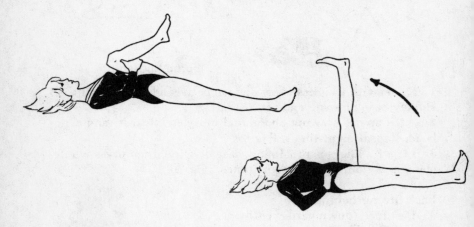

Hips And Legs

1 **Leg Pulling** Lying on the back on the floor in a straight line
from head to feet (which are relaxed), lift the right leg, with bent
knee, towards the chest (hands under the thigh) and give it
sixteen small pulls, higher each time. Repeat with left leg.

Repeat the same pulls but with both legs straight and heels
stretched, sixteen times on either side.

2 **Leg Lifting** Lift alternate legs, swinging as high as possible,
knees straight, heels stretched, eight times.

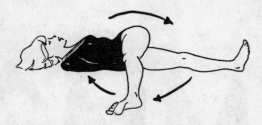

3 Leg Circling Circle right leg across left and round (as wide a circle as possible) out to right side and back to the floor, keeping *both* knees straight and heels stretched, leg on floor steady. Repeat eight times alternately.

4 Leg Lifting Sideways Roll over on to right side, body in a straight line from toes to right arm stretched overhead, left hand in front on floor as a support. Lift the left leg up from the hip as high as possible (toe pointed) and recover, eight times. Repeat on other side, eight times.

Lying on right side again, swing left leg backwards and forwards, knee straight, eight times. Repeat on other side, eight times.

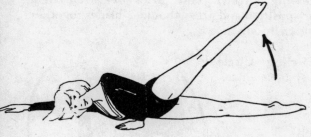

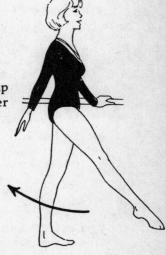

5 Hip Swing Standing, holding a support, hip swing forward and back, eight times on either side.

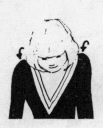 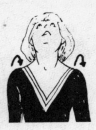 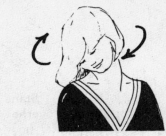

Head, Shoulders, Waist

6 **Shoulder Roll** Standing, feet together, roll both arms (from shoulder-joints) forward, then back, head dropping forward and back, eight times.

7 **Head Circling** Feet apart, roll the head slowly and heavily, forward and round to right. Repeat left. Repeat all four times.

8 **Shoulder Pressing** Stretch both arms overhead. Bend elbows to a square position and press shoulder-blades together, three times. Repeat all four times.

9 **Shoulder Circling** Circle arms backwards sixteen times.

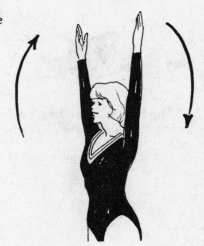

10 Waist Bending Waist bend from side to side, one hand under armpit, the other stretching down the leg, sixteen times.

11 Cross-Swing Standing position, arms in a high 'V' overhead. Drop arms, crossing in front of body and bending knees, to one count, breathing out. Lift again slowly to 'V' for three counts, straightening knees and breathing in. Repeat all four times.

Repeat all with a deep swing, bending towards floor, hands brushing floor on the first count, then lifting slowly to high 'V' for the next three counts. Repeat four times.

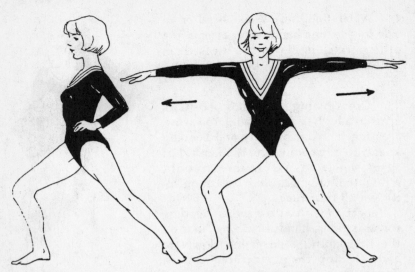

12 Lunges Lunge forward on right leg (keep left heel on ground) and press seven times, then recover. Repeat left.

Legs in wide stride, a swinging lunge from side to side eight times.

These exercises take five minutes to do and I try to practise them in front of an open window so that my skin gets an airing as well.

The technical points to remember are central control, rib lift, full stretch of arms and legs, freedom of movement.

I hope you will enjoy doing them as much as I do.

1 Hip roll Sitting with body upright and knees straight, roll from side to side, hands touching floor. Repeat sixteen times. (Fig. 1)

2 Hip walking From the same sitting position, walk forward with straight knees, elbows bent, arms in opposition to legs. Repeat eight times forward, and eight back. (Fig. 2)

Hip Slimming, Waist Stretching

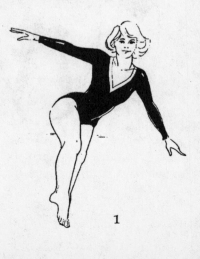

1

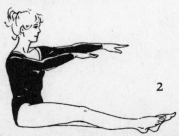

2

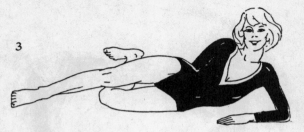

3

3 Hip cycling Lying on one hip, supported on elbow, cycle with legs off floor. Repeat sixteen times. (Fig. 3)

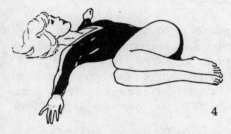

4

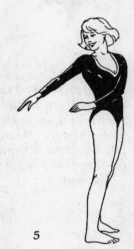

5

4 Hip rolling Lying with knees on chest, arms at shoulder-level and palms to floor, roll both knees to floor on right side, keeping knees together and shoulders on floor. Repeat to left side. Repeat all eight times. (Fig. 4)

5 Waist rotation Standing with feet slightly apart, turn waist, arms and head to right side, keeping hips facing front. Repeat to left. Repeat all eight times. Keep movements continuous, with a swing. (Fig. 5)

6 Figure of 8 swing Swing both arms from a stretch overhead on right side to drop across body to left side. Lift overhead to left, drop across body to right. Lift to stretch on right, and repeat this figure of 8 swing in a continuous movement. Repeat eight times. (Fig. 6)

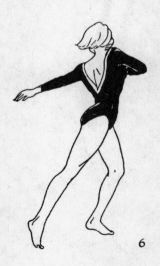

6

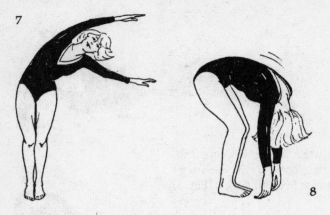

7 Waist bend Waist bend to right side, left arm curved overhead, knees slightly flexed. Repeat on other side, other arm overhead. Repeat all eight times. (Fig. 7)

8 Spine curl Bend body forward, knees flexed, arms and head relaxed. Uncurl spine to an upright position, lifting arms overhead and stretching waist. Relax forward. Repeat four times. (Figs 8–9)

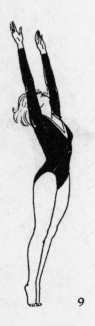

POST NATAL EXERCISES

After your baby is born you will need at least twelve hours rest before commencing the following exercises, which are designed to help your body return to normal following pregnancy and childbirth.

These exercises should be practised slowly several times a day for at least six weeks after the birth. The doctor, midwife or physiotherapist will tell you if there are any that you should not do and teach you additional ones if they think this is necessary.

Days 1-3 inclusive. Repeat each exercise five times

1 Pelvic Floor Exercise The pelvic floor muscles through which your baby was born become very stretched during pregnancy and this occasionally results in loss of bladder control or a prolapse in later life. You should practise this exercise even if you have had a caesarian operation or stitches.

In any position – lying, sitting or standing – slowly tighten the muscles (as though you were trying to stop yourself passing water). Continue to tighten these muscles and hold tightly for five seconds, then relax. Repeat frequently.

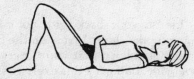

2 Deep Breathing Lie on your back with your knees bent and your hands on your waist. Take a deep slow breath in and feel your hands being pushed up. Breathe out and feel your hands sink down. This exercise helps re-expand the lower parts of your lungs which were restricted during pregnancy.

3 Ankle Exercises To help the circulation in your legs. Lie with your legs out straight, or sitting with back supported.

(a) Bend and stretch your toes.
(b) Bend your feet up and down from the ankles.
(c) Circle each ankle.

4 **Tummy Muscle Exercises** To help you regain your figure. Lie on your back with your knees bent. Press the small of your back on to the bed, tighten your tummy muscles, then relax. May also be done sitting and standing.

Day 4 Onwards add the following exercises

5 **Hip Hitching** Lie on your back with one knee bent and the other flat on the bed. Keeping this leg straight and on the bed, hitch the whole leg up towards the waist, making it shorter. Then do the same with the other leg.

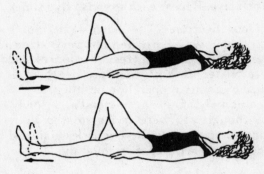

6 **Hip Rolling** Lie on your back with your knees bent and together. Keeping your shoulders firmly on the bed, roll over on to one hip as far as possible so that your knees touch the bed. Repeat on the other side. Later try this exercise sitting with back supported.

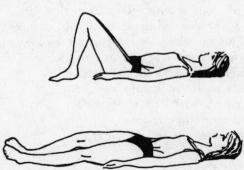

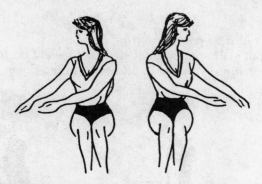

7 Arm Swinging Sit on a chair and swing your arms around from side to side, twisting at the waist.

8 Bending Sideways
Stand with your feet
slightly apart. Bend side-
ways keeping your back
straight and sliding each
hand in turn towards the
side of the knee. Head re-
laxes sideways too.

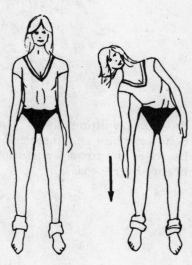

Remember:

To rest as much as possible during the day.
To stand 'tall' with your weight slightly forward on to the balls
of your feet, tummy pulled in and seat tucked down.

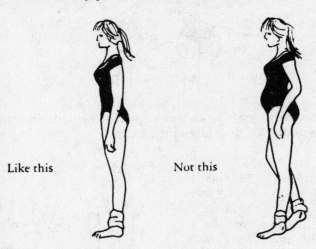

Like this Not this

Avoid heavy lifting.
Bend your hips and knees and keep your back straight.
Exercises for correct posture are taken in every Health and
Beauty Exercise class.

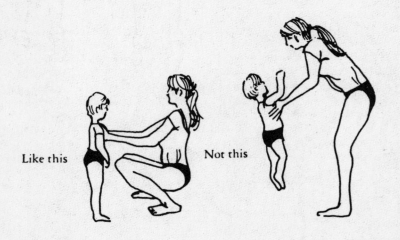

Like this Not this

MAKE-UP ROUTINE

Here, for what it is worth, is the routine which I follow each morning. It takes only five minutes.

Those who like a foundation (cream or liquid) should match it carefully to their skin colour, trying varying strengths until they suit their exact skin tone. Winter and summer types will need a pinky-blue based foundation, autumn and spring a golden-beige one.

1 *Clean*. I use a good cleansing lotion, or cold water. (This last increases the circulation of the blood to the skin.)

2 *Moisturize*. This is more important as you grow older for the skin tends to dry up. I use an enriched moisture cream as a base all over my face rather than a heavy foundation cream. I smooth it on with my fingers.

3 *Cover* any blemishes such as brown marks or thick freckles with a quick corrector the same colour as your skin, dabbing it on the offending places and then blending in. (I have one shaped like a lipstick.)

4 *Cream* with a light cream (skin colour) any prominent parts of the face which need more protection than the moisturizer gives. I use it on my nose, which always gets sunburned, cheek-bones and chin.

5 *Apply make-up* where you need emphasis. Use a brush for this and imagine you are painting a picture! For cheeks, have a blush rouge which suits your colouring and the rest of your make-up. Apply this blush lightly with your soft paint-brush across your cheek-bones, up over the temple and down to the jaw-bone. Smooth with fingers in a circular movement to the roots of the hair. All must blend in. For lips, you can use a lipstick or a brush again (a smaller one) to outline the lips, then fill in with the lipstick. Dab off any excess and use the lipstick sparingly, careful that the colour tones in with your own colouring rather than with the clothes you are going to wear. For eyes, eye shadow is useful for emphasis, but again must be used discreetly and must tone in with your eye colour. Eye shadow usually comes in boxes of several shades. I use a darker one on the back of the lid and on the underbrow and a lighter one near the eye. After they are applied, I blend the two colours together with a finger-tip; I find this gives a softer effect than colouring the eye-lid with one colour only. Mascara should also complement your eyes and be carefully applied. Eye make-up is meant to enhance the eyes not smother them! I aim for a natural look during the day. In the evening eye make-up can be more pronounced.

6 *Powder* very lightly over nose, forehead and round the mouth with a small brush. (You can dip this brush in the powder afterwards and then

take it wrapped in a tissue in your handbag for the rest of the day.) A natural transparent powder is best, or one with a slight colour to blend with your make-up.

In this routine do not forget your neck. Moisturizer and cleanser should extend to the neck and throat also – even a light dusting of powder there is not amiss.

RELIEVING STRESS

There are times when life becomes too much for us and we get caught in a vicious circle of activity or worry which we seem unable to break. One good way of tackling this condition is to try to take a whole day off. This may mean being ruthless about abandoning family or work or obligations but it will be worth it if your stressful condition is relieved.

All you need for your day of rest is a quiet warm bedroom with a window which you can open wide. You are going to be alone for the whole day, with the telephone off the hook and no clock, watch, radio, or TV screen visible. You must remain undisturbed; no one should share your vigil, except perhaps your cat, if you have one. Cats understand the kind of relaxation and contemplation you will experience!

First you have to unwind, and there is no better way of doing this than watching a cat stretching itself, turning into different positions, experimenting with movements and finally relaxing. Copy it. Lying on the floor, stretch to your fullest extent, yawn, feel tension in your extended arms and legs. Then relax. Do this several times until you clearly experience the difference between tension and relaxation in your body.

Next take several deep breaths, filling and emptying your lungs. Then go through the relaxation sequence described in Chapter 3 on page 47. At the end of that you should be completely relaxed in body but you may still be tense in mind. Open your window wide, lean out and look at the sky. Sense its height and space, the slow deliberate movements of the clouds, its vastness in comparison with the world below. Breathe deeply again, imbibing its space. Then (before you freeze!) lie down on your warm bed, get really comfortable, close your eyes and let sleep or dreams come.

During the day you can read, as long as what you read is quiet and relaxing, not too exciting or over-stimulating. You should be in a drowsy, dream-laden frame of mind and you will not want to be shaken out of it. Eat sparingly – have a tray in your room with fruit, cheese and biscuits, fruit-juice or water.

Most of the time you will sleep. If your mind begins to race and make a list of the things you should be doing, turn it firmly away from those thoughts. Listen to some music, quote some poetry to yourself, remember a picture you specially like, or a really happy event. What you are trying to do is to summon up the healing powers of your unconscious. They are there and they will work for you if you quietly and gently get out of their way.

Several times during the day practise the relaxation sequence lying on

the floor; and breathe deeply, either there or at the open window. When the day fades make yourself a light meal if you are hungry, and have a relaxing hot bath. Last thing before you turn out your light (which can be quite early), go through your relaxation sequence once again, this time in bed. Sleep will come and sustain you throughout the night. And when you wake next morning try to treasure the memory of your day off before you plunge into activity once more.

THE SEVENTIES AND ONWARDS

There is no reason why you should not exercise in your seventies and beyond, provided that you understand the rules of good posture (see pages 18/20) and put them into practice. All the exercises in my daily dozen may be safely performed, although numbers 1–4 may be more comfortable if practised on a bed rather than on the floor. The lunging exercise (no. 12) should be done with care to avoid any straining of the hips, knees or thighs.

All the other exercises described in this book can be practised by older people used to physical exertion, provided they remain within comfortable limits. For example, it may be necessary to reduce the tempo and make fewer repetitions of each exercise. For those who are inactive and would sooner exercise in a sitting position from a chair, I strongly recommend Lesley Hilton's book *Easy Does It* (already referred to in chapter 7), which contains exercises illustrated and explained by Pat Rowlandson, a senior Health and Beauty Exercise teacher. Here is her account of a class which she takes in a day centre. I include it in the hope that it will be of interest to older people and may inspire them (even if they suffer from some illness or disability) to join such a class. Many are available in different parts of the country.

Southwark Day Centre Class

The members of the class are in their seventies, eighties and occasionally nineties. They are mainly chairbound and include two stroke cases who have very limited movement. Other ageing problems which I have encountered include overweight due to lack of exercise, angina, high blood pressure, arthritic joints, Parkinson's disease, poor sight and deafness, and in a few cases loss of memory. The numbers participating range between ten and twenty, mainly single or widowed people. They generally live alone in small flats or sheltered homes and attend the day centre once or twice a week from mid-morning until tea-time. Most come in by ambulance.

The premises are exceptionally good. We have one large main room which is light and airy and is used for meals and various activities. The dedicated and efficient staff help to make the atmosphere happy and relaxed.

The exercise class takes place once a week from 1.15–2.45 p.m. Everyone is encouraged to join in and work within their own ability. It took some time to convince the members of the value of exercise for them. Many felt that at their age and in their state of health it would be a waste of time. Those who were willing to have a go felt self-conscious

under the sceptical eyes of the unconverted. However, this problem was soon overcome by using music which appealed to everyone. It is rare now for anyone in the room to sit out, although many are fairly limited in their movements.

The class plan I usually follow consists of:

1 *Warming and loosening* This is taken very gently with plenty of repetition so as not to confuse, and is always done to a rousing piece of music (Souza marches, champagne gallops, etc.). I then give a brief explanation of the next section.

2 *Posture* This consists of sitting tall and relaxing back into the chair, gaining an awareness of how to mobilize the lumbar spine (which gets very set when sitting all day). We then practise tummy contractions, and overhead stretching with a lift of the ribs for those who can manage it.

3 *Feet, ankles, knees and hips* These are exercised while resting the arms and trunk.

4 *Waists* This involves gentle flexion, rotation and back extension.

5 *Hand and Wrist Exercises* These are again performed resting the trunk, and are followed by elbow, shoulder, head and neck work.

6 *General Exercise* This is a five-minute session, incorporating as much as possible of what we have learnt, in an easy work-out usually taken to bright, cheerful music. A slow section is included and everyone joins in at some stage.

7 *Cool Down* A quiet finish with deep breathing and relaxation, this is taken once again to a popular tune – something slow and romantic.

The class pattern varies slightly from week to week but the members like to do the exercises they know and can manage easily without causing discomfort. We quite often perform movements with scarves, which everyone enjoys. The length of the class depends on the feedback from the members. Any signs of undue tiredness or slight apathy, and we have a break for general discussion, either on the benefits of exercise or on individual interests and problems. This is generally conducted over a cup of tea for which we are all ready at the end of the class!

RECOMMENDED READING

Doris Pooser, *Always in Style*, Piatkus Books.

Carole Jackson, *Colour Me Beautiful*, Piatkus Books.

Gayle Hunnicutt, *Health and Beauty in Motherhood*, Viking.

Nancy Kohner, *Having a Baby*, BBC Publications.

Judy Priest (ed.), *The Baby Annual*, Shropshire Publications. (Available from the National Childbirth Trust.)

Valerie Grove, *The Compleat Woman*, Chatto & Windus.

Shirley Price, *Practical Aromatherapy*, Thorsons.

Chris Stevens, *Alexander Technique*, Macdonald Optima.

Dr Miriam Stoppard, *50 plus Lifeguide*, Dorling Kindersley.

Lesley Hilton, *Easy Does It*, Macdonald Optima.

Patty Fisher and Arnold Bender, *The Value of Food*, O.U.P.

Professor Robert E. Ornstein, *The Healing Brain*, Macmillan.

USEFUL ADDRESSES

HEALTH AND BEAUTY EXERCISE
(formerly the Women's League of Health and Beauty)

Walter House
418–22 Strand, London WC2R 0PT 01-240 8456

Classes throughout Britain. Teachers' training courses also available.

S.T.Y.L.E.
(Stretching, Toning, Young, Lively Exercise)

Mrs Lucy Martin
21 Bunting Close, Ogwell, Newton Abbot, Devon TQ12 6BU
 0626-62656

Classes for teenagers and young mothers (crèches available) taught by
Health and Beauty Exercise teachers nationwide.

EXTEND
(Exercise Training for the Elderly and Disabled)

1A North Street, Sheringham, Norfolk NR26 8LJ 0263-8224791

Classes in day centres and hospitals for senior citizens nationwide. Also
training courses for teachers.

THE MEDAU SOCIETY

8B Robson House, East Street, Epsom, Surrey KT17 1HH 0372 729056

Classes in Medau rhythmic movement to music with balls, clubs and
hoops.

THE KEEP FIT ASSOCIATION

16 Upper Woburn Place, London WC1H 0QG 01-387 4349

Classes run by KFA qualified teachers.

THE SOCIETY OF TEACHERS OF THE ALEXANDER TECHNIQUE

10 London House, 266 Fulham Road, London SW10 9EL 01-351 0828

Specialized teaching of good posture.

THE BRITISH WHEEL OF YOGA

1 Hamilton Place, Boston Road, Sleaford, Lincs NG34 7ES 0529-306851

Largest list of registered yoga teachers in the United Kingdom.

THE OPEN UNIVERSITY

Central Enquiry Service, PO Box 71, Milton Keynes, Bucks MK7 6AG
0908-653231

The Open University runs both degree courses and shorter courses, with material transmitted on TV and radio. Also local tutorials, meetings and summer schools.

THE SPORTS COUNCIL

16 Upper Woburn Place, London WC1H 0QG 01-388 1277

Leaflets giving advice on various sports.

CITIZENS' ADVICE BUREAUX

National Association of Citizens' Advice Bureaux, 115–23 Pentonville Road, London N1 9LZ 01-833 2181

Information on local offices, which will provide details of what is available locally.

HEALTH EDUCATION AUTHORITY
Hamilton House, Mabledon Place, London WC1H 9TX 01-631 0930

Information on health, nutrition and exercise.

AGE CONCERN (England)

60 Pitcairn Road, Mitcham, Surrey CR4 3LL 01-640 5431

Information and advice concerning older people.

NATIONAL CHILDBIRTH TRUST

Alexandra House, Oldham Terrace, London W3 6NH 01-992 8637

Helpful advice on the various options for childbirth.